IMAGES
of America

WINGS
OVER FLORIDA

IMAGES
of America

WINGS
over FLORIDA

Lynn M. Homan
and Thomas Reilly

ARCADIA
PUBLISHING

Published by Arcadia Publishing
Charleston, South Carolina

Printed in the United States of America

Library of Congress Catalog Card Number: 99-63940

For all general information contact Arcadia Publishing at:
Telephone 843-853-2070
Fax 843-853-0044
E-Mail sales@arcadiapublishing.com
For customer service and orders:
Toll-Free 1-888-313-2556

Visit us on the Internet at www.arcadiapublishing.com

CONTENTS

Acknowledgments 6

Introduction 7

1. Florida's First Fliers 11

2. A Call to War 21

3. The St. Petersburg-Tampa Airboat Line 33

4. The Roaring Twenties 41

5. Florida Takes to the Air 55

6. The Golden Age of Flight 69

7. Flying in the Forties 85

8. War 97

9. Space 111

10. Wings over Florida 121

ACKNOWLEDGMENTS

A book such as *Wings Over Florida*, which celebrates Florida's rich and unique aviation history, could not have been written without the assistance of many people. We are grateful to Arcadia Publishing and our editor, Christine Riley, for having the foresight to believe that *Wings Over Florida* deserves a place in their publishing catalogue.

Florida has many wonderful museums possessing excellent photographic collections. Those museums whose collections proved especially valuable include: the Florida State Archives, the International Sport Aviation Museum, the St. Petersburg Museum of History, and the Tampa Bay History Center. Few libraries can claim a better collection of photographs than the Tampa-Hillsborough County Public Library System's Burgert Brothers' Collection, and we are thankful for the opportunity to use them. Embry-Riddle Aeronautical University and Paul Camp, archivist of the University of South Florida's Special Collections, have been immensely helpful.

Florida has always been more hospitable to African-American aviators than most southern states. The many original airmen residing in Florida, including Nasby Wynn, Henry Bohler, and especially, Hiram Mann, have been so instrumental in our understanding of the contributions made by the Tuskegee Airmen. Ruth Clifford Hubert, Dorothy Ebersbach, and Marion Tibbets graciously shared favorite photographs and stories about women in aviation, most notably the Women Airforce Service Pilot (WASP) program in which they participated during World War II. William Kidney, a Civil Air Patrol historian, has been instrumental in helping us understand the contributions of the CAP fliers during the war. Thanks also to the United States Air Force and Navy for the use of their photographs.

The people at the National Aeronautics and Space Administration were superb in their assistance. We are indebted to Ken Thornsley and Margaret Persinger of the Kennedy Space Center, and Debbie Dodds of the Johnson Space Center for their assistance. Thanks also to the *Tampa Times*, the *Lakeland Ledger*, Peter J. Sones Jr., M.D., the crew of the MetLife airship, Seminole-Lake Gliderport, and Brenda Geoghagan of the Hillsborough County Aviation Authority. As always, we marvel at the work that Kelly, Bruce, and the staff of Zebra Color Photo Lab perform with old photographs. Their skill helps to make our books what they are.

Edward C. Hoffman Sr., president of the Florida Aviation Historical Society, should be considered as the dean of Florida's aviation history. His input and support are always priceless.

INTRODUCTION

Florida became the southern Mecca of aviation just a few years after the Wright brothers' successful flight in a heavier-than-air machine. It's easy to understand why. The weather was almost perfect, with hundreds of days each year that were suitable for flying. The state also possessed relatively flat land and natural, ready-made runways on the beaches of the Atlantic Ocean. Following a logical progression, neophyte American aviators started in the North, and slowly made the southward trek.

Florida's aviation history is even older than its statehood. The "Sunshine State" was admitted to the Union on March 3, 1845. In September 1840, Colonel John Sherburne developed a plan to use balloons during the Second Seminole War; his plan was never put into effect, however. Lighter-than-air flight originated in Florida at Jacksonville on January 28, 1878, when a balloon drifted over the city. Other aviation firsts in Florida soon followed. As John A.D. McCurdy piloted his airplane over Palm Beach in February 1911, he transmitted the first air-to-ground wireless message. The first night flight of an airplane took place in Tampa in March 1911. The rickety biplane was piloted by Lincoln Beachey, the fearless Curtiss exhibition flier.

The world's first scheduled passenger airline, the St. Petersburg-Tampa Airboat Line, began operation on January 1, 1914, in St. Petersburg. Using a pair of Benoist flying boats over a 21-mile route between St. Petersburg and Tampa, the airline carried 1,205 passengers and logged over 11,000 air miles. While the St. Petersburg-Tampa Airboat Line's operation lasted only for a three-month period, it was nonetheless, a very important event in the world of aviation. It proved, perhaps for the first time, that the airplane really had a purpose, a use other than as an attraction for audiences morbidly hoping to see an aviator killed in a crash at frivolous county fair air shows. Then, as now, the safety of an airline is of paramount importance. The operators of the airline and the pilot, Tony Jannus, constantly stressed the need for safety.

Chalk Airways, the world's oldest international airline, began in Miami in 1919. On June 1, 1926, Florida Airways provided the first daily air-passenger service in the United States to be operated over a federal airmail contract route.

In the early days of aviation, if there was a record to set, Florida was frequently the place to do it. Not only did the world's first scheduled airline begin there in 1914, but two years earlier, Robert Fowler concluded the first west-to-east coast flight in Jacksonville. Few aviation records have been longer lasting than that set by Walter Lees and Frederic Brossy. On May 25, 1931, the duo lifted off the sands of Jacksonville Beach at 6:47 a.m., not to return to the ground for three and a half days.

Florida's military training bases made many significant contributions to the state's aviation history. Naval aviation came into being at Pensacola in 1914. After more than 80 years as an active naval yard and depot, the Pensacola Navy Yard closed on October 20, 1911, with only a small group of caretakers remaining. Two years later, a board of officers recommended to Secretary of the Navy Josephus Daniels " . . . the establishment of an Aeronautic Center at Pensacola." Over $1 million was requested to establish the program. The navy agreed and ordered an aviation unit to be sent from Annapolis, Maryland, to Pensacola. Nine officers and 23 enlisted men arrived on January 20, 1914, outfitted with seven aircraft and several portable hangars. Lieutenant Commander Henry C. Mustin commanded the air station as well as the battleship *Mississippi*. Ensign Godfrey de C. Chevalier made the first flight at Pensacola on February 2. The *Pensacola Journal* reported that " . . . the machines in the air looked like giant buzzards."

Officers and enlisted men based at Pensacola were soon called into action. On April 21, 1914, an aviation detachment departed for Veracruz, Mexico. Lieutenant Patrick N.L. Bellinger commanded a small group consisting of one pilot, three student pilots, and two aircraft to be used for observation and scouting missions. A day earlier, Lieutenant John Towers and a similar detachment left Pensacola aboard the *Birmingham* headed for Tampico, Mexico.

Fortunately for the navy, Secretary Daniels strongly believed in the usefulness of Pensacola and naval aviation. By December 1915, the station had grown from a small detachment, to an aviation unit that included 15 aircraft, 121 mechanics, and 19 qualified aviators. By the end of 1916, the table of organization and equipment at Pensacola included 58 officers, 431 enlisted men, 33 seaplanes, and several balloons. The training facility was capable of training 64 aviators and 64 mechanics every six months.

When, with a stroke of the pen, President Woodrow Wilson declared war against Germany on April 6, 1917, America's aviation forces were ill-prepared for combat. The navy had fewer than one hundred airplanes in its fleet; the army had less than 250 airplanes. There were only 131 officers and 1,097 enlisted men in the aviation section of the Army's Signal Corps. In May 1917, the United States ranked 14th among the nations of the world in terms of aviation. That would quickly change.

After the United States entered the war in 1917, a mad rush began to train aviators for European action against the Germans. Throughout the country, aerial training facilities were quickly designed and built. Because of the ideal weather and relatively flat terrain, Florida was selected for several bases. Civilian flight trainers served at the Glenn Curtiss flight school, teaching army sergeants the art of flying in Miami and the Everglades. Prior to, and during World War I, military flight training took place at Pensacola, Miami, Key West, and Arcadia. Testing of the world's first guided missile took place in 1919 at Carlstrom Field, Arcadia.

During World War II, the war effort involved most of Florida, as many new bases were opened to meet the demand for trained military pilots. MacDill Field opened in Tampa in 1939. Lakeland's Drane Field was home to a fleet of B-24 bombers. Gen. Jimmy Doolittle trained for his famous raid against Tokyo at Eglin Field, Panama City. By the end of World War II, approximately 30,000 naval aviators had earned their wings at Pensacola Naval Air Station.

Florida has hosted numerous men and women who have been instrumental in furthering aviation. Ruth Elder, Mabel Cody, Jacquelyn Cochran, Juan Trippe, Eddie Rickenbacker, Tony Jannus, Jimmy Doolittle, Laurie Yonge, and Lincoln Beachey; the well known, and hardly known, all made contributions. Several of these men and women have been honored with the prestigious Tony Jannus Award, an annual tradition since 1964. Sponsored by the chambers of commerce of St. Petersburg and Tampa, the award recognizes an individual for his or her contribution to commercial aviation.

Imagine being called Florida's "Lindbergh"—pretty heady stuff for a flier from Haines City in 1933, only six years after Charles Lindbergh's conquest of the Atlantic Ocean. That's exactly how the *Orlando Sentinel* characterized Peter J. Sones in 1933, as he rapidly became one of the South's best-known aviators. While not Floridians by birth, both Charles Lindbergh and

Amelia Earhart spent much of their time in Florida. Lindbergh was of inestimable value to Juan Trippe as he helped to turn Pan American Airways into a giant airline. Earhart departed Miami on her ill-fated round-the-world flight. Bessie Coleman, unarguably the best known of early African-American pilots, lost her life in an aviation accident at Jacksonville in 1926.

"Meet me in Miami" became the rallying cry for thousands of civilian and military fliers each January. Some of the greatest American and foreign fliers attended the annual All-American Air Maneuvers each winter, an uninterrupted aviation tradition since 1929. The 14th annual event, scheduled for January 9–11, 1942, was canceled only because of war.

Beaches have been used as natural airports and runways since the first heavier-than-air flights. On December 17, 1903, Orville Wright used the dunes of Kitty Hawk, North Carolina, to prove that man could fly. Florida's beaches quickly became convenient runways. Charles K. Hamilton first used Ormond Beach on January 17, 1906, when he was hoisted aloft in a glider. Using the beaches as runways made sense as there was little cost. With wide sandy expanses packed nearly as hard as cement, the beach runways stretched for miles. Smooth as tabletops, the beaches were relatively maintenance free. Florida's airports have come a long way since those early days of flying. Today Tampa, Orlando, and Miami boast some of the most modern airports in the world.

Florida has produced more airlines than perhaps any other state. National Airlines, Eastern Air Lines, and Pan American World Airways were all founded during the first 25 years of Florida's aviation history. A symbol of progress, Pan Am's early history was characterized as romantic and full of adventure. At one time, Pan American was the most recognized corporation in the world. Sadly, those airlines that were once so well known have disappeared. Likewise, just as many small, unheralded commuter and cargo airlines have been born in Florida. Arrow Air, Challenge Air Cargo, Florida Airlines, Dolphin, Florida Airways, Intercity Airlines, Mackey Airlines, and many others have carried hundreds of thousands of tons of cargo, plus thousands of passengers.

Florida was a natural breeding ground for aviation. With good weather virtually all year long, Florida became a natural hopping-off point between the industrial Northeast and South and Latin America. Warm winter weather and tropical sandy beaches had long been a destination for the wealthy escaping from the cold and dreary Northeast and Midwestern winters. When airlines such as National pioneered low-cost coach fares and affordable prearranged hotel packages, Florida became a full-fledged tourist destination for everyone with the urge to escape inclement weather.

Heavier-than-air aviation did not originate in Florida; neither did American space exploration. With the launch of a V-2/WAC Corporal from Cape Canaveral in July 1950, however, it was realized that Florida was ideal for space launches. Florida's contributions to the conquest of space have been every bit as significant as that of the other contributions made in Florida since the beginning of aviation. While obviously far more sophisticated than the early days of flight from Florida's beaches and cow pastures, space exploration during the latter half of the 20th century has held just as many unknowns. The threat of death has been just as real to space pilots. Many of Florida's early aviation pioneers, including Tony Jannus, Lincoln Beachey, Bessie Coleman, and Albert Whitted, suffered premature deaths at the controls of an airplane while trying to do things that had perhaps never been done before. Space flight has been just as dangerous.

Americans regarded space launches from Cape Canaveral with a false sense of security until they received a rude awakening on January 27, 1967, when Apollo 1 astronauts Virgil Grissom, Edward White, and Roger Chaffee perished in a horrible fire on the ground. Almost 20 years later, the explosion of the space shuttle *Challenger*, only minutes after launch from the Kennedy Space Center, became a pivotal moment in American space exploration. Millions of Americans on January 28, 1986, saw the *Challenger* explode over Florida, resulting in the loss of Michael Smith, Dick Scobee, Ronald McNair, Ellison Onizuka, Christa McAuliffe, Gregory Jarvis, and Judith Resnik.

As the world readied to enter a new millennium, the 21st century, space travel took on a new, almost more exciting, phase than ever before. John H. Glenn, the oldest astronaut and first American to orbit the earth, prepared for another mission 36 years after his first space flight on February 20, 1962. As part of the shuttle *Discovery* crew, Glenn returned to space on October 29, 1998. Once again, as Floridians had done virtually since the time of the Wright brothers' first flight, people rejoiced with *Wings Over Florida*.

One

Florida's First Fliers

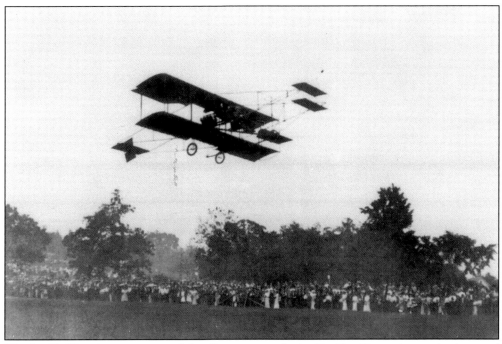

Charles K. Hamilton was one of the first men to fly in Florida. Since the sandy shores of the Atlantic Ocean made an excellent, unobscured runway, Hamilton used Ormand Beach for his experiments with gliders as early as 1906. As pictured, the legendary pilot performed frequent flying exhibitions at Jacksonville. Hamilton, a one-time dirigible pilot, circus parachute jumper, and trick bicyclist, was small in stature, had blazing red hair, and big ears. A consummate showman, he had a propensity for alcohol and was seldom seen without a cigarette hanging from his lips. Trained by Glenn Curtiss, Hamilton was the 12th pilot to be licensed to fly in America. Despite reportedly having broken every bone in his body in aviation accidents, Hamilton died not from injuries, but from pneumonia on January 22, 1914. (Private Collection.)

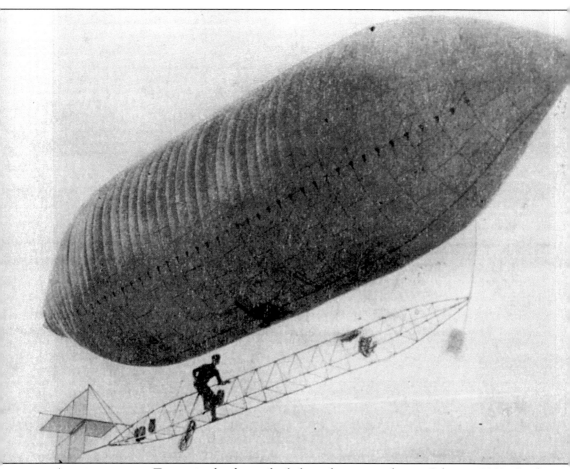

Aviation came to Tampa in the form of a lighter-than-air airship in February 1910. As the city celebrated the Great Panama Canal Exposition, thousands of people turned out to see dirigibles, balloons, and a promised flight of a Curtiss biplane. On the afternoon of February 14, E.J. Parker piloted the Stroebel dirigible past the Tampa Fairground's grandstands at an altitude of only 20 feet above the field. Then, despite a heavy breeze, Parker ascended and flew over Tampa. As Frank Goodale piloted a second dirigible past the grandstand, he steered toward the minarets of the Tampa Bay Hotel and then crossed the Hillsborough River toward Ybor City. The remaining pilot, Stanley Vaughn, tilted the nose of his dirigible upward and in minutes attained an altitude of several hundred feet. With three airships in the air, the flight was described as "spectacular in character." The highlight of the event, however, was the nighttime dirigible flight guided by a powerful searchlight. Promising to bring another flying extravaganza to Tampa the following year, Charles J. Stroebel stated, "Climatic conditions in South Florida during the winter months are as near perfect for airship flights as could be desired." (Private Collection.)

The best-known early exhibition flyer, Lincoln Beachey brought his Curtiss Flyer to Tampa in February 1910 as part of the Great Panama Canal Exposition event. On December 27, 1908, over Jacksonville, he piloted the first motor-propelled airship to fly in Florida. In February 1910, the first heavier-than-air flight in Florida took place in Orlando when he won a $1,500 prize for keeping his Curtiss-built, pusher biplane in the air for five minutes. Returning to Tampa in March 1911, Beachey made the first publicly viewed night flight in an airplane. (Burgert Brothers Collection, Tampa-Hillsborough County Public Library System.)

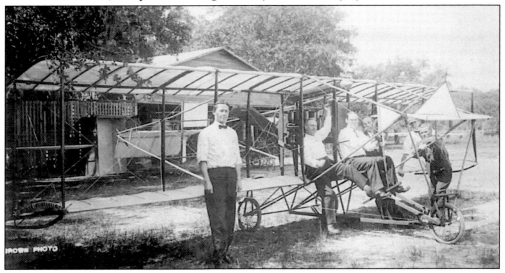

This home-built biplane, displayed outside a private hangar at Kissimmee in 1910, was not much more advanced than the one used by the Wright brothers in 1903. On July 17, 1908, the *Kissimmee Valley Gazette* reported a proposed municipal ordinance intended to regulate "the height over the city within control of the law and set the amount of licenses to be paid by owners of aircraft." Although never adopted, that ordinance gave Florida the dubious distinction of being the birthplace of aviation legislation. (Florida State Archives.)

13

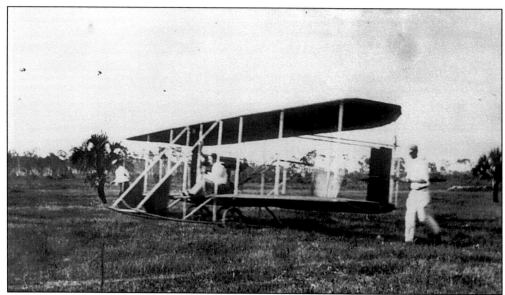

Fair managers and promoters frequently hired aviators to insure large crowds at their events. Howard Gill, of Baltimore, Maryland, was trained by the Wright brothers and became part of the Wright exhibition team that toured the United States. When Gill was retained to fly his skeleton-framed pusher biplane in celebration of Miami's 15th anniversary in 1911, he received $7,500 for making the first airplane flight over the city. (Florida State Archives.)

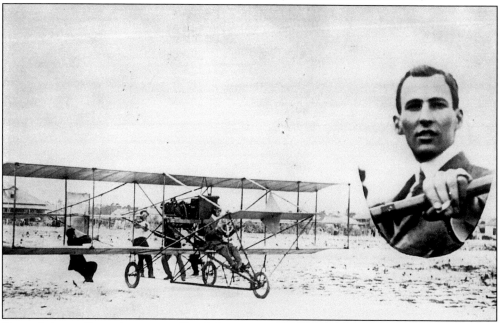

One of the earliest pioneers in Florida's aviation history was not a Floridian or even an American. John A.D. McCurdy, a Canadian, first came to Florida to fly in March 1911. Over Palm Beach, McCurdy transmitted the first air-to-ground wireless message from an airplane. A month later, McCurdy and Jimmy Ward were the first aviators to fly in St. Augustine when they performed an aerial exhibition with their Curtiss pushers on April 2, 1911. (Embry-Riddle Aeronautical University.)

From left to right are Frank Gotch, Max Lillie, and Robert Fowler. Max Lillie brought his Wright Model B to Jacksonville and opened the city's first flying school at the Moncrief Racetrack in the spring of 1912. On February 8, 1912, as Robert Fowler prepared to end his record-setting transcontinental flight at Moncrief Park, Lillie and Harold Kantner were engaged in a flying exhibition. (Private Collection.)

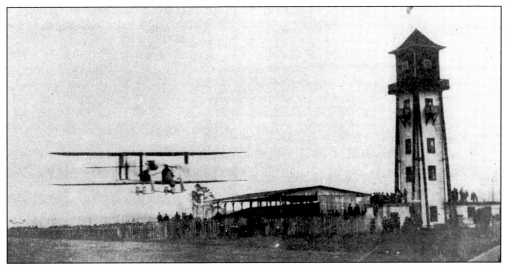

In 1911, William Randolph Hearst offered a $50,000 prize in the *New York American* to the first aviator able to successfully fly across America before October 11, 1911. Robert G. Fowler attempted to accomplish this feat in a Wright Model B, leaving San Francisco at 1:37 p.m. on September 10, 1911. Fowler did not meet the deadline, but he did become the first aviator to complete a west-to-east transcontinental flight, landing in Florida on February 8, 1912, at Moncrief Park, Jacksonville. (Private Collection.)

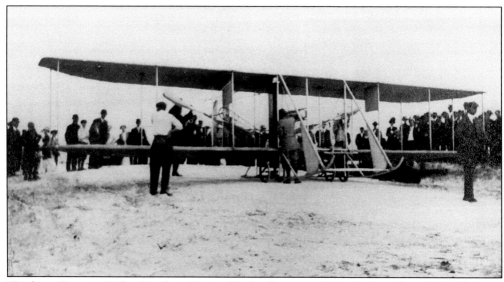

"Birdman Bonney Defies Death in Daring Flights," screamed the *St. Petersburg Daily Times* on February 23, 1912. Leonard W. Bonney in his Wright biplane was the first aviator to fly over St. Petersburg, treating the citizenry to all kinds of thrills, including spiral glides, the Dutch roll, figure-eights, and volplaning (gliding). Witnessed by five thousand people, Bonney's flight took place on February 17. It was the first time that most people in the area had seen an airplane in flight. (Private Collection.)

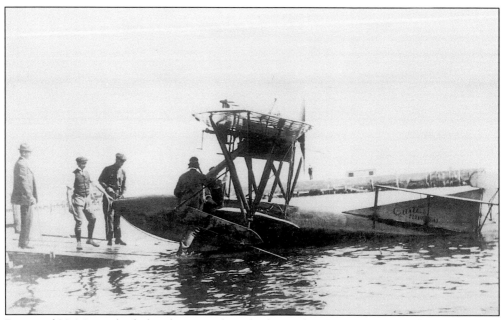

Raymond V. Morris (in helmet) prepared to climb into his Curtiss M monoplane flying boat at the St. Petersburg yacht basin in February 1914. Along with the pilots of the St. Petersburg-Tampa Airboat Line, Morris and his 22-foot aircraft competed for the aerial attention of St. Petersburg's residents in early 1914. After Morris and his flying boat left St. Petersburg that April, the monoplane flying boat was ultimately converted into a biplane. (Florida Aviation Historical Society.)

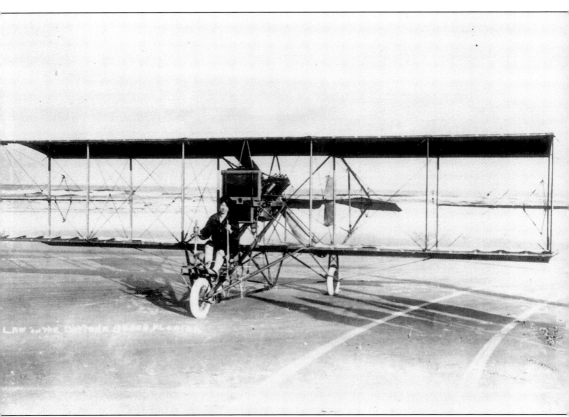

Ruth Bancroft Law landed her Curtiss Model E pusher biplane on Daytona Beach in 1915. Famous in her own right, she was the sister of F. Rodman Law, a daredevil parachutist and stunt pilot nicknamed the "human fly." Ruth Law held an impressive list of firsts for women fliers, claiming several early altitude and distance records. Law, who took her first flight on July 5, 1912, was also the first woman to fly at night in Florida. The fifth woman to receive an Aero Club of America license to fly, she became the first woman to pilot an airplane in Florida on November 12, 1912. On December 17, 1915, at Seabreeze, Florida, she entered the record books as the first woman to loop an airplane. Law is also credited with being the first woman to pilot an airplane from which a parachutist was dropped. (Florida State Archives.)

Johnny Green built his own airplane and barnstormed through Tennessee before receiving hydroplane instruction at the Curtiss Flying School in Miami. While there, he bought the *Betty*, a Curtiss Model F flying boat named after his wife. Green flew in Fort Pierce, advertising real estate sales, before arriving in St. Petersburg in 1915. Green bought a second flying boat in 1917 and christened it the *Sunshine*. (Private Collection.)

Johnny Green and his passenger Frank Westcott prepared for a flight in the flying boat *Betty* on January 30, 1916. During the mid-20s, Green became an aerial gun-runner delivering illegal guns to Key West and ships at sea, for eventual routing to Mexico. In 1926, the "Great Hurricane" destroyed the *Sunshine*. Shortly after, the *Betty* was destroyed by fire. (Private Collection.)

The boxy, all-enclosed flying boat built by the Lawrence-Lewis Airplane Company of Chicago was tested in Florida. Initial evaluations on Tampa Bay on February 15, 1918, proved satisfactory. The next day, test pilot James D. Smith readied the flying boat for an aerial check flight. As Smith prepared for takeoff, the engine backfired and flames engulfed the aircraft. The Lawrence-Lewis was completely destroyed, becoming a $12,500 junk heap. (Private Collection.)

Jack McGee and a passenger prepared for a flight in an early Curtiss F flying boat. In 1918, Jack McGee flew his flying boat in St. Petersburg, using the old wooden hangar opposite the St. Petersburg yacht basin as his base of operations. The hangar had originally been built by the city to house the Benoist flying boats used by the St. Petersburg-Tampa Airboat Line in 1914. (Florida Aviation Historical Society.)

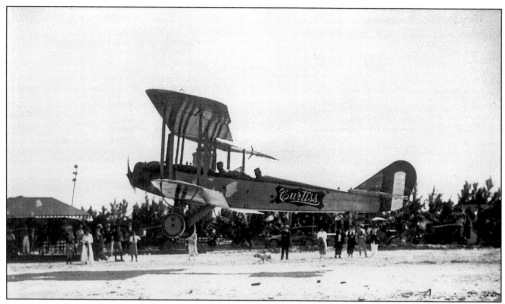

Most of the military aerial training during World War I was accomplished with the Curtiss JN-4D Jenny. Hundreds of pilots went through flight training and learned the intricacies of flight with the Jenny, Thomas Morse pursuit aircraft, and Handley Page bombers. After the war, the military-surplus Jennies quickly became a favorite airplane for civilian fliers. (Private Collection.)

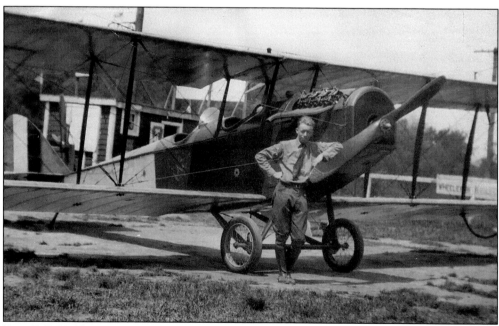

Russell F. Holderman is posed in front of his Curtiss JN-4 in 1919. Holderman was an Early Bird, an aviation pioneer, a WW I flight instructor, a barnstormer, an airmail pilot, and a naval reserve pilot. Having made his first solo flight in 1913, Holderman was frequently seen flying over Sarasota as he advertised local real estate. (Embry-Riddle Aeronautical University.)

Two

A CALL TO WAR

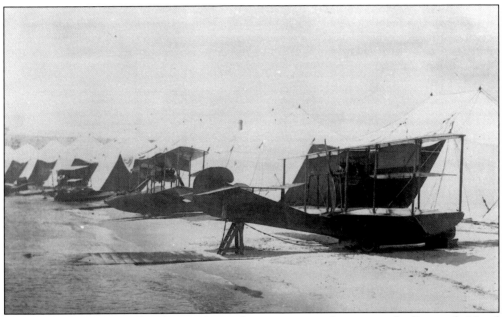

Curtiss flying boats were lined up in front of temporary tent hangars at the Pensacola Naval Air Station in 1914. On October 7, 1913, Secretary of the Navy Josephus Daniels appointed a board of officers to develop an organizational plan for a Naval Aeronautic Service. Two weeks later, the board recommended the "establishment of an Aeronautic Center at Pensacola for flight and ground testing, and for the study of advanced aeronautic engineering." Secretary Daniels announced on January 10, 1914, that "the science of aerial navigation has reached that point where aircraft must form a large part of our naval force for defense operations." An aviation unit of 9 officers, 23 enlisted men, and 8 Curtiss flying boats soon arrived in Pensacola aboard the USS *Mississippi* and USS *Orion*. The crew of the emerging air station, commanded by Lieutenant Commander Henry C. Mustin, quickly erected tents and portable canvas hangars. By the end of 1915, the station had grown from a small detachment to 19 qualified aviators, 121 mechanics, and a fleet of 15 aircraft. (Florida State Archives.)

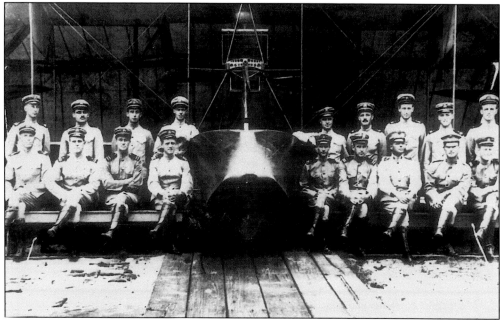

The first class of naval aviators at Pensacola Naval Air Station consisted of 18 officers. Sitting left to right are Saufley, Bellinger, Whiting, Mustin, Read, Johnson, Cunningham, Evans, and Haas. Standing left to right are Paunack, Spencer, Bartlett, Edwards, Bronson, Corry, Norfleet, McDonnell, and Scofield. (Florida State Archives.)

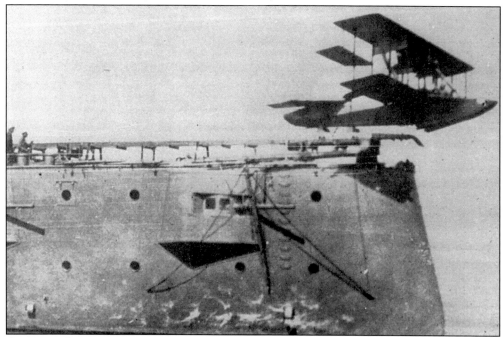

On November 6, 1915, in a Curtiss flying boat, Lieutenant Commander H.C. Mustin, the first commanding officer of Pensacola Naval Air Station, made the first catapult launch of an aircraft from a vessel under way. The USS *North Carolina* was in Pensacola Bay at the time of the historic flight. (Florida State Archives.)

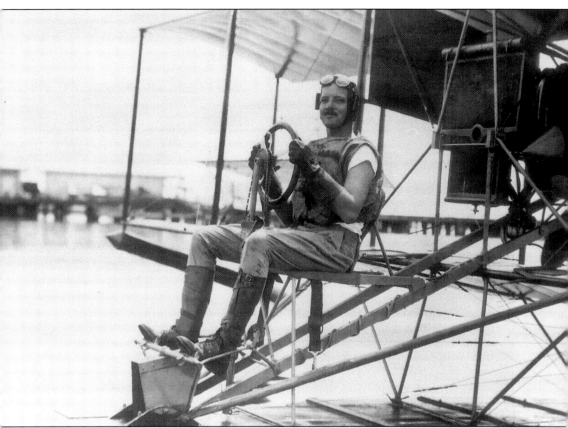

Beginning his aviation career in 1914, Lieutenant Commander William M. Corry Jr. was the 23rd naval aviator to earn his wings. Shown at the controls of a Curtiss pusher hydroplane in 1915, Corry was the first Floridian to enter naval air training at Pensacola Naval Air Station. When a crash in 1920 enveloped his hydroplane in flames, Lieutenant Commander Corry died while trying to rescue his passenger. Following the tradition of naming military fields for aviators killed in the line of duty, Pensacola's Corry Field was named in his honor on December 7, 1922. Posthumously, Lieutenant Commander Corry was also awarded the Medal of Honor. (Florida State Archives.)

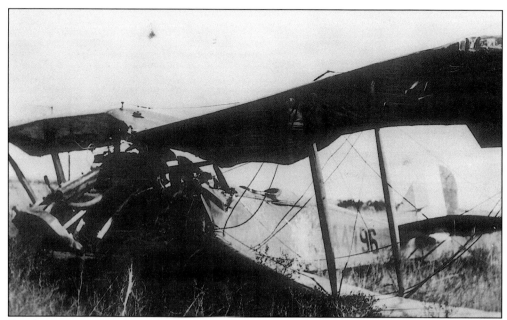

Death was a constant threat for fliers at Pensacola Naval Air Station. The first fatality occurred when Lieutenant Junior Grade J.M. Murray crashed into Pensacola Bay in a Burgess D-1 flying boat. The *Pensacola Journal* reported, "hundreds of horrified spectators saw the machine taking a normal glide but suddenly its nose turned downward and struck the water with a terrific force." During 1917 alone, 21 student aviators died at Pensacola in flying accidents; nearly 58,000 flying hours were recorded as were 148 crashes. (Private Collection.)

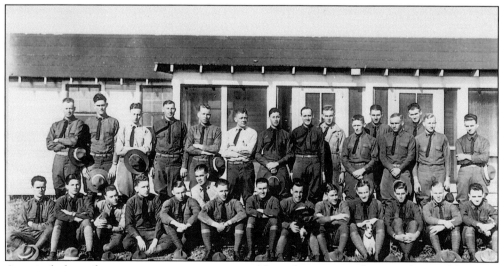

A typical class of prospective aviators are posed here for a group photograph. In addition to being able to fly, aviators had to learn principals of flight, including major causes of accidents and how to avoid them. Pilots also were required to be aware of the phenomena known as "air holes." Many of those who made it through training were soon killed in combat. (Private Collection.)

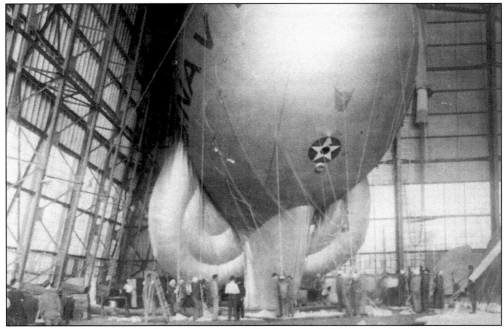

A naval dirigible entered a floating hangar at the Pensacola Naval Air Station. The floating dirigible hangars were 60 feet by 140 feet and drew 18 inches of water. The waterborne dirigible hangars rested on floats that were towed to sea when the blimps were ready to take off. Pensacola was the site of all naval dirigible training until 1921. (Florida State Archives.)

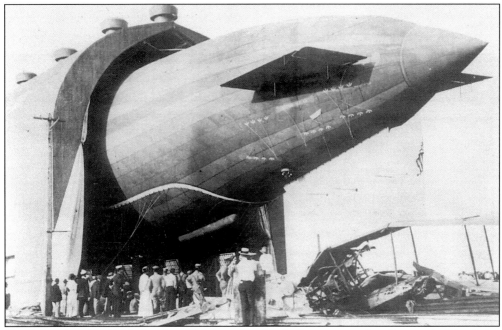

On December 14, 1916, the first DN-1, a dirigible balloon, arrived at Pensacola Naval Air Station. A steel hangar had been erected on a large barge that was moored in the shipyard's dry dock. The dirigible made its first successful flight at Pensacola on April 20, 1917, and was accepted for service by the United States Navy on May 16, 1917. (Private Collection.)

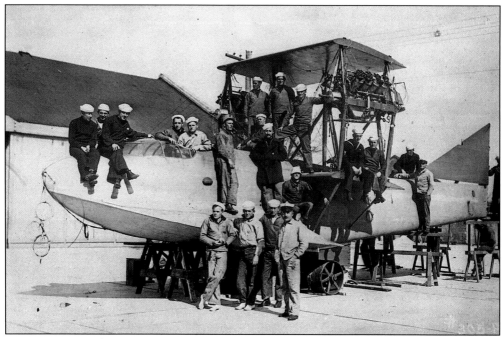

Crews at Pensacola trained on the four-passenger Curtiss H-12 flying boats that were used for aerial patrols and bombing missions. The flying boat, with a wingspan of almost 100 feet, was equipped with four .30-caliber Lewis machine guns. The H-12 could be armed with four 100-pound, or a pair of 230-pound bombs. (Private Collection.)

In 1914, Pensacola became the site of America's first naval air station. Three years later, Sturdevant seaplanes lined up in front of the first permanent hangars at Pensacola Naval Air Station. The B.F. Sturdevant Company, which had a long history manufacturing both airplanes and engines for civilian use, was well-known for the reliability of its engines. (Florida State Archives.)

When the United States declared war against Germany on April 6, 1917, construction at the Aeronautic Center at Pensacola took on a frenzied pace. The table of organization and equipment included 58 officers, 431 enlisted men, and 39 seaplanes. By the end of the war in November 1918, over one hundred buildings had been constructed. The base was now home to 438 officers, 5,559 enlisted men, and 215 airplanes. (Private Collection.)

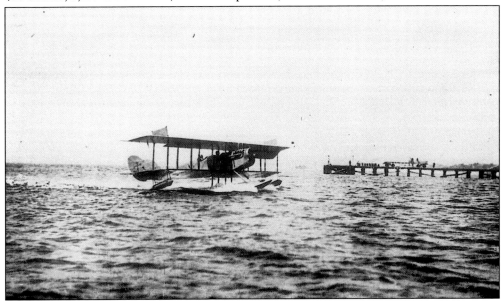

During World War I, the Curtiss-built N-9 was the standard primary trainer used by the navy at Pensacola Naval Air Station to train its pilots. The aircraft was a Curtiss Jenny outfitted with a large center pontoon and wing pontoons. The two-passenger seaplane was capable of a top speed of 70 miles per hour. (United States Navy.)

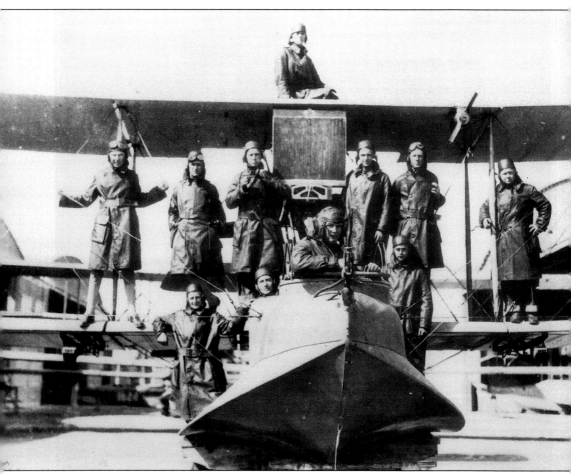

Toward the end of 1918, naval pilot training was curtailed; night flight instruction at Pensacola Naval Air Station was discontinued. Following the signing of the armistice, pilot trainees were allowed to complete their instruction. The assignment of new students ended however. By 1919, flight training at Pensacola had returned to its pre-war levels; approximately 150 men went into the training program annually. The station shrank to 70 officers, 700 enlisted men, 500 civilian employees, and a fleet of 90 aircraft. As orders for new aircraft were canceled, public auctions of surplus equipment were held. During the war, over one thousand HS-2 flying boats had been manufactured by Curtiss, L.W.F. Engineering, Standard, Gallaudet, Boeing, and Lougheed. When new, the 39-foot-long HS-2 flying boats cost approximately $30,000; after the armistice, they were available for one-third that amount. A number of the flying boats ended up at the Curtiss Flying School in South Florida, where they were used to train civilian pilots such as these. (Private Collection.)

When America entered World War I, the country was ill-prepared for battle. The United States had few pilots, and its small fleet of airplanes was generally obsolete. Since pilots had to be quickly trained, military fields in Florida were constructed almost overnight. At the height of pilot training, hundreds of Curtiss Jennies filled the skies over Dorr and Carlstrom Fields at Arcadia. (Private Collection.)

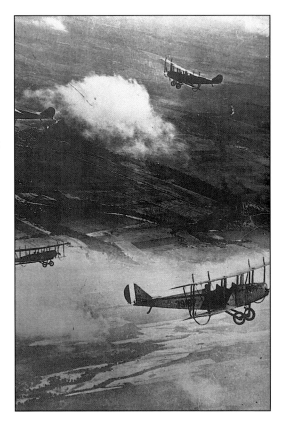

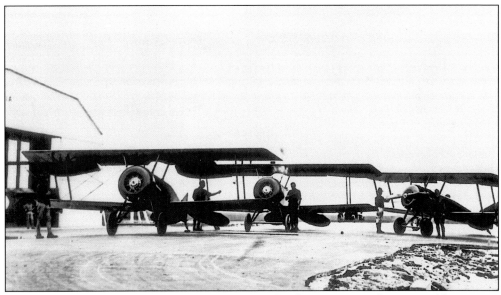

Dorr and Carlstrom Fields were twin training sites for the U.S. Army during World War I. In keeping with military tradition, Dorr Field was named in honor of Stephen Dorr, killed in a midair collision on August 17, 1917. Carlstrom Field was named for the Swedish-born Victor Carlstrom, killed in an aircraft accident at Newport News, Virginia, on May 19, 1917. (Florida State Archives.)

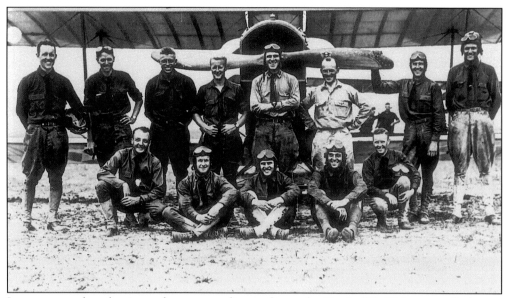

Instructors and graduating cadets are standing in front of a Curtiss JN-4D Jenny at Carlstrom Aviation Field, Arcadia, June 16, 1918. During World War I, the United States constructed 35 flying fields. Started in 1917 and completed by early 1918, Carlstrom Field and neighboring Dorr Field were used to train army aviators. (Florida State Archives.)

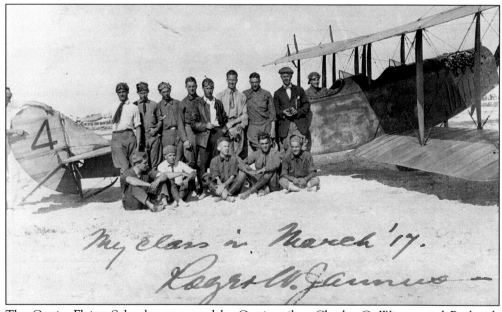

The Curtiss Flying School was opened by Curtiss pilots Charles C. Witmer and Beckwith Havens on January 12, 1912, to train civilian pilots. Originally located at NW 17th and 20th Street in Miami, the flying school relocated to Hialeah in 1917. Many of the men who went on to serve as military pilots received their initial flight training at the school. (Private Collection.)

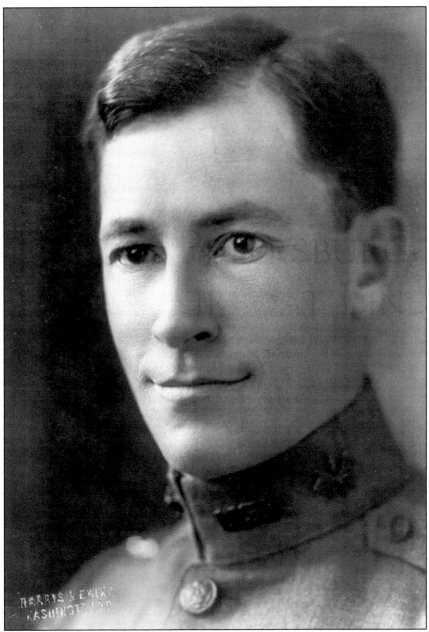

Along with younger brother Tony, Roger Weightman Jannus was a pilot for the St. Petersburg-Tampa Airboat Line. Until Tony's death, Roger's aviation career shadowed that of his brother. Early in 1917, Roger became a civilian flight instructor at the Curtiss Flying School in Miami. There he developed, or at least perfected, a maneuver by which to pull an aircraft out of a tailspin, a problem for pioneer fliers. On June 19, 1917, Roger Jannus enlisted in the Aviation Branch of the United States Signal Corps. After training at Selfridge Field, Michigan, and Ellington Field, Texas, Captain Jannus shipped out for France. Assigned to the pursuit school at Issoudon, France, he piloted the DeHavilland 4, nicknamed the "flying coffin." On September 18, 1918, Captain Roger Jannus was killed in the flaming explosion of his aircraft over Field Number 7 at Issoudon. (Private Collection.)

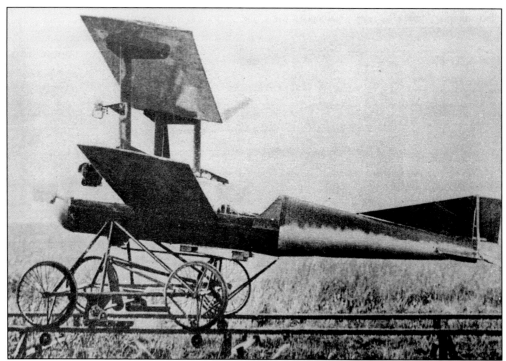

As early as 1919, guided missile tests were conducted in secrecy at Arcadia's Carlstrom Field. The first flight of a guided missile took place there in September 1919. The pilotless airplane with bomb-carrying capability was remotely controlled by radio. The project was developed under the watchful eyes of Lawrence Sperry and Charles Kettering. (Private Collection.)

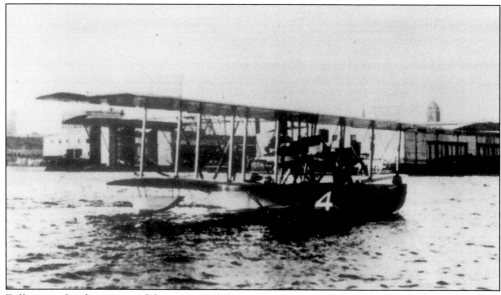

Following the first successful crossing of the Atlantic Ocean by air in 1919, the crew of the Curtiss NC-4 flying boat visited Jacksonville on October 28, 1919. The crew, led by Lieutenant Commander A.C. Read, landed in the St. John's River at the foot of Jacksonville's Market Street. Thousands of Floridians turned out to visit the flying boat. (Private Collection.)

Three

THE ST. PETERSBURG-
TAMPA AIRBOAT LINE

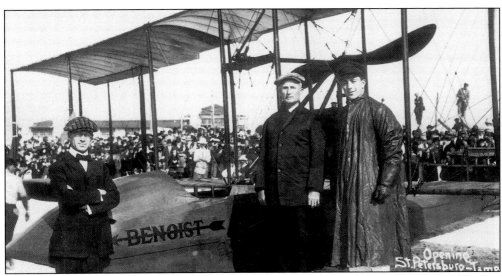

Posing for the inaugural flight of the St. Petersburg-Tampa Airboat Line, the world's first regularly scheduled airline, were (left to right) the following: Percival Elliott Fansler, the airline's business manager; Abram Cump Pheil, the first passenger; and Tony Jannus, the pilot. Thousands of people lined St. Petersburg's waterfront early on the morning of January 1, 1914, in anticipation of the airline's first flight from St. Petersburg to Tampa. Prior to the departure of the flight, a spirited auction had been held for the right to be the airline's first passenger on the 21-mile flight. The ex-mayor of St. Petersburg, Abe Pheil, won the first ride with a bid of $400. In advance of such a momentous accomplishment, several individuals made the predictable laudatory speeches. Fansler told the assembled crowd, "The Airboat Line to Tampa will be only a forerunner of great activity along these lines in the near future . . . what was impossible yesterday is an accomplishment of today —while tomorrow heralds the unbelievable." (Florida Aviation Historical Society.)

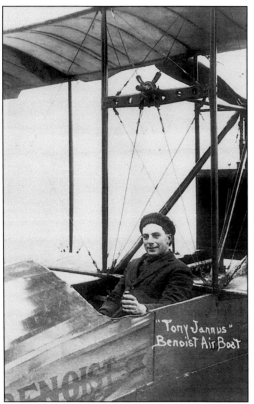

Antony Habersack Jannus was born in Washington, D.C., in 1889, and taught himself to fly in a Rexford Smith biplane in 1910 at College Park, Maryland. A year later, Jannus moved to St. Louis as the chief pilot for the Benoist Aircraft Company. His record-setting 1,973-mile flight from Omaha, Nebraska, to New Orleans, Louisiana, in 1912 received prominent newspaper coverage. On January 1, 1914, with the inauguration of the St. Petersburg-Tampa Airboat Line, Tony Jannus entered history books as the world's first airline pilot. (Florida Aviation Historical Society.)

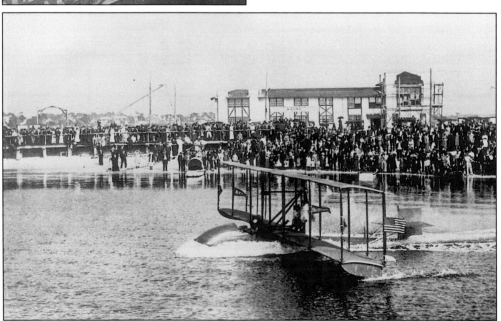

Just a few minutes before 10 a.m. on January 1, Tony Jannus stood up in the bow of the Benoist flying boat. Dressed in a long black slicker, he pulled down on the starting bar and the flying boat's 75-horsepower Roberts engine cranked over. At exactly 10 o'clock the flying boat slid through the calm water of St. Petersburg's yacht basin. (Florida Aviation Historical Society.)

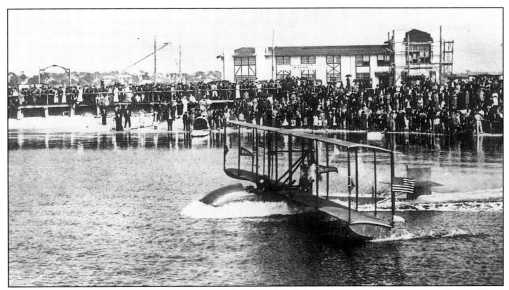

Jannus and Pheil waved to the crowds as they took off from St. Petersburg's waterfront. They reached Tampa less than half an hour later, as an anxious crowd back in St. Petersburg awaited news of their arrival. Years later, Percival Fansler recalled, "At 10:26 a.m. the telephone rang and my elation could not be concealed as I heard the attendant at the Tampa terminal say, 'Tony's coming up the river, and there's a big crowd yelling their heads off.'" (Florida Aviation Historical Society.)

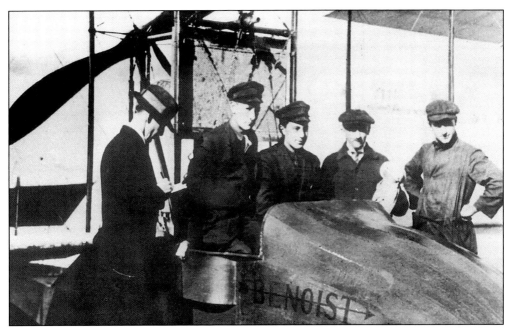

Virtually from the beginning, the success of the St. Petersburg-Tampa Airboat Line has been attributed almost solely to Tony Jannus. In fact, the St. Petersburg-Tampa Airboat Line was very much a team effort. Pictured in January 1914 (left to right) were Tom Benoist, Roger Jannus, Tony Jannus, Heinrich Evers, and J.D. Smith, all of whom were instrumental in the success of the world's first airline. (Private Collection.)

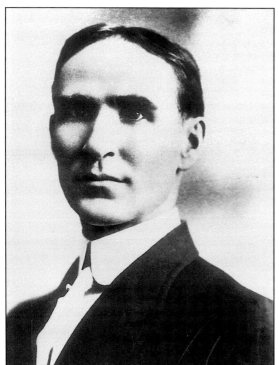

The Benoist Aircraft Company provided the flying boats used by the St. Petersburg-Tampa Airboat Line. Although Thomas Wesley Benoist's company had its headquarters in St. Louis, he saw the airline as a way of attracting publicity and potential aircraft sales. An airline operation in St. Petersburg could lead to additional operations in other areas and require additional aircraft. The Benoist company was "ready to extend their airlines all over Florida," using St. Petersburg as a hub. (Florida Aviation Historical Society.)

Percival Elliott Fansler was the entrepreneur responsible for bringing the world's first scheduled airline to St. Petersburg. On December 4, 1913, Fansler arrived in St. Petersburg with a proposal for a scheduled passenger airboat operation between the Florida cities of St. Petersburg and Tampa. Four days later, Fansler and city officials signed a contract creating the St. Petersburg-Tampa Airboat Line. Two weeks later, the world's first scheduled airline became a reality. (Florida Aviation Historical Society.)

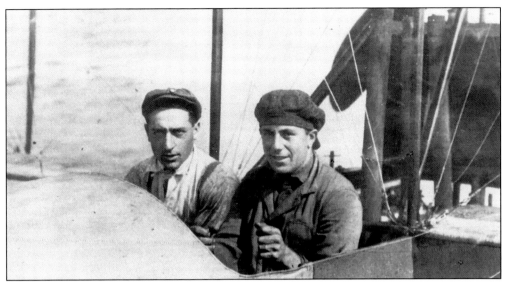

Called "Smitty the Infallible" by Tony Jannus, and "Jay Dee" by nearly everyone else, James D. Smith served as the "mechanician" for the St. Petersburg-Tampa Airboat Line. Smith was hired as a mechanic for Tony Jannus in 1911, accompanying him as Jannus performed hundreds of aerial exhibitions in 1912 and 1913. Smith eventually earned his own pilot's certificate, performing routine flying and test pilot work for several aircraft manufacturers. (Florida Aviation Historical Society.)

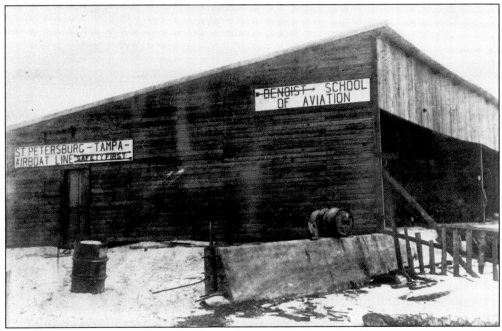

In order to allow the St. Petersburg-Tampa Airboat Line to begin flying, a contract was drawn up between the airline's operators and St. Petersburg's Board of Trade. The contract obligated St. Petersburg " . . . to build a hangar on the sea wall of the North Mole to house the airboats when not in operation . . ." From his office in St. Louis, Tom Benoist personally drew up the plans for the hangar's construction. (Florida Aviation Historical Society.)

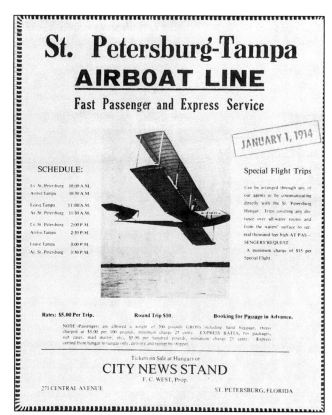

St. Petersburg-Tampa
AIRBOAT LINE
Fast Passenger and Express Service

JANUARY 1, 1914

SCHEDULE:

Lv. St. Petersburg 10:00 A.M.
Arrive Tampa 10:30 A.M.

Leave Tampa 11:00 A.M.
Ar. St. Petersburg 11:30 A.M.

Lv. St. Petersburg 2:00 P.M.
Arrive Tampa 2:30 P.M.

Leave Tampa 3:00 P.M.
Ar. St. Petersburg 3:30 P.M.

Special Flight Trips

Can be arranged through any of our agents or by communicating directly with the St. Petersburg Hangar. Trips covering any distance over all-water routes and from the waters' surface to several thousand feet high AT PASSENGERS' REQUEST.

A minimum charge of $15 per Special Flight.

Rates: $5.00 Per Trip. Round Trip $10. Booking for Passage in Advance.

NOTE—Passengers are allowed a weight of 200 pounds GROSS including hand baggage, excess charged at $5.00 per 100 pounds, minimum charge 25 cents. EXPRESS RATES, for packages, suit cases, mail matter, etc., $5.00 per hundred pounds, minimum charge 25 cents. Express carried from hangar to hangar only, delivery and receipt by shipper.

Tickets on Sale at Hangars or
CITY NEWS STAND
F. C. WEST, Prop.

271 CENTRAL AVENUE ST. PETERSBURG, FLORIDA

As indicated in the airline's advertisement, a one-way trip between St. Petersburg and Tampa was $5; a round-trip was double. Between Monday and Saturday, two daily round-trip flights were scheduled. Sundays were used to perform maintenance on the flying boats and offer special sightseeing flights. (Private Collection.)

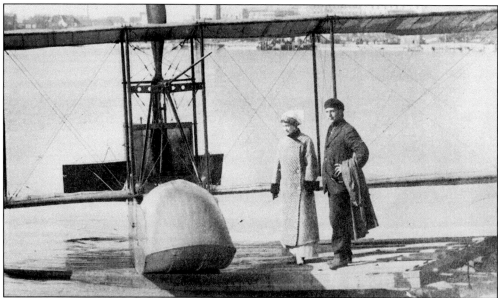

The airline's first woman passenger, Mae Peabody of Dubuque, Iowa, arranged for a charter flight with Tony Jannus on January 2. During its three months of operation, the airline proved that it could carry passengers on a scheduled basis and that a demand for such a service existed. The two machines used by the St. Petersburg-Tampa Airboat Line logged a total of 11,000 miles and carried a total of 1,205 passengers. (Florida Aviation Historical Society.)

When the St. Petersburg-Tampa Airboat Line carried a cargo of 22 pounds of ham and 18 pounds of bacon from Swift & Company in Tampa to the Hefner grocery store in St. Petersburg, national news coverage followed. Hefner's new advertising slogan proclaimed, "Although they came high, the price is low." (Private Collection.)

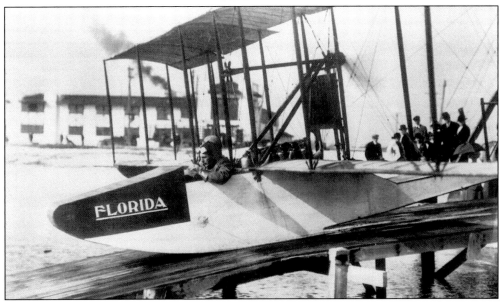

Demand for service was so strong that Tom Benoist shipped two additional flying boats to St. Petersburg toward the latter part of January. Number 43 and Number 45 were used for both scheduled and chartered passenger services. On March 31, in accordance with the contract terms, the St. Petersburg-Tampa Airboat Line made its last flight. Renamed the *Florida*, Benoist Number 45 was sold to L.E. McLain. (Florida Aviation Historical Society.)

After the airline ceased operation, Jannus and his brother Roger founded Jannus Brothers Aviation. After a brief return to St. Petersburg in January 1915, Tony Jannus went to work for the Curtiss Aeroplane Company as a test pilot. On October 12, 1916, Jannus was killed when the Curtiss H-7 flying boat he was piloting crashed into Russia's Black Sea. The three-month life of the St. Petersburg-Tampa Airboat Line had changed commercial aviation forever. From the experiment by Fansler, Benoist, Jannus, and forward-thinking businessmen, St. Petersburg pioneered a new means of public conveyance. Each year, the chambers of commerce of St. Petersburg and Tampa honor an individual with the Tony Jannus Award for contributions to commercial aviation. (Private Collection.)

Four

THE ROARING TWENTIES

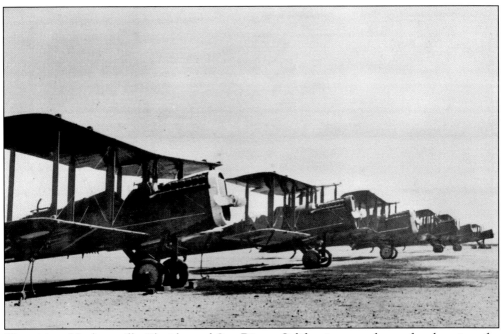

The cities of Jacksonville, Florida, and San Diego, California, were the perfect locations for record-setting transcontinental flights, since the distance between these two cities is the shortest route from coast-to-coast. Several fliers had already flown the course, each time setting a new speed record. In a DeHavilland DH-4B similar to these, Army Lieutenant William DeVoe Coney flew from San Diego, California, to Jacksonville on February 24, 1921, in the record-setting time of 22 hours and 27 minutes. One month later, on the return flight, Lieutenant Coney, assigned to the 91st Aero Squadron, crashed and was killed in Crowley, Louisiana. Unfortunately, Coney's record was soon eclipsed on September 5, 1922. (United States Air Force.)

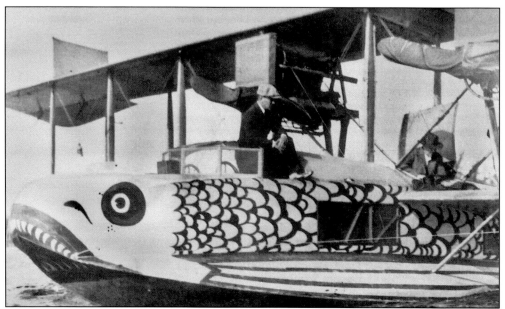

Founded by the very wealthy Rodman Wanamaker in 1916, America Trans-Oceanic Company included service from both Long Island, New York, and West Palm Beach, Florida. Using Curtiss HS-2L and H-16 flying boats in its service, the company's most popular route during prohibition was from Florida to Bimini and Cuba, where Americans could legally drink alcohol. ATO's 11-passenger H-16 flying boat named the *Big Fish* was used on daily service between Miami and Bimini until it was destroyed in a crash in New York. (Private Collection.)

Joseph Tillis Jr. poses next to his home-built monoplane in DeLand on August 30, 1921. Designed and constructed by Tillis, the airplane was powered by a two-cylinder, twenty-horsepower Indian motorcycle engine. Although this was not the use envisioned by the engine manufacturer, such adaptations were not uncommon. (Florida State Archives.)

42

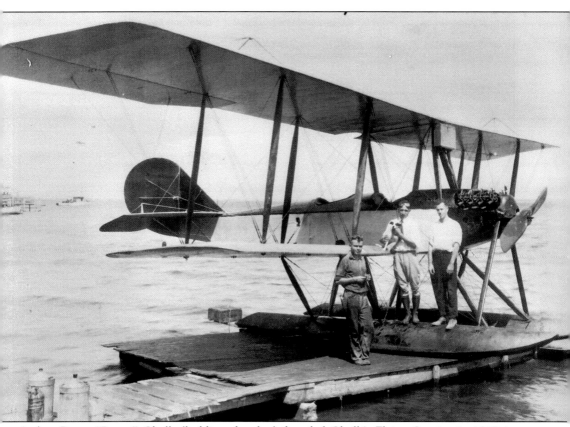

Arthur Burns "Pappy" Chalk (holding the dog) founded Chalk's Flying Service in 1919 in Miami. Flying between Miami and the Bahamas, Chalk's laid claim to the title of the world's oldest international airline, a boast disputed by companies such as KLM and Avianca. In the 1920s, he moored his three-seat Curtiss HS-2L float-plane at Watson Island, along the MacArthur Causeway linking Miami and Miami Beach. A beach shack served as the airline terminal for those seeking to evade prohibition for the legal rum trade in the Caribbean islands. Taught by Tony Jannus, Chalk learned to fly in 1912 in Paducah, Kentucky, in a Benoist flying boat. By the time that Pappy Chalk retired in 1964 at the age of 75, he had logged 16,800 flying hours and claimed a perfect safety record. (Private Collection.)

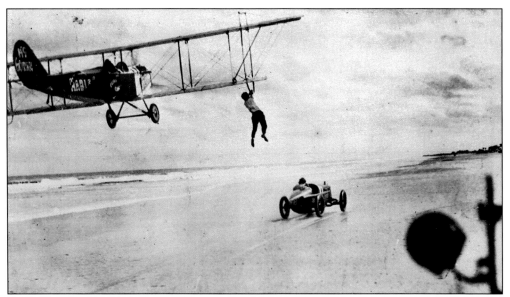

Louis "Bugs" McGowan, a member of the Mabel Cody Flying Circus, could always be counted on for a death-defying show. A self-taught flyer, McGowan performed the auto-to-plane-with-ladder trick during the fall of 1921 at Daytona Beach. He died at the age of only 21 in July 1923, in a midair explosion. (Florida State Archives.)

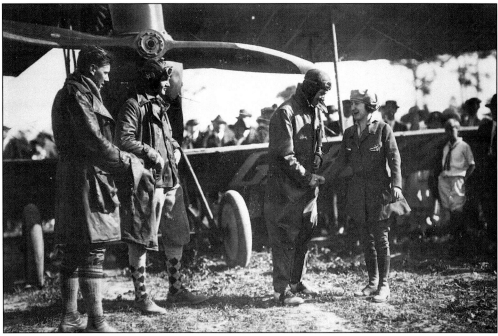

Mabel Cody and her Flying Circus thrilled thousands of people with her aerial daredevil stunts. The circus featured night flying, wing-walking, automobile-to-airplane transfers, parachute drops, and acrobatic loop-the-loops. On March 24, 1924, while performing an automobile-to-airplane stunt at a speed of 70 miles per hour, Mabel Cody fell from an altitude of 50 feet. After her recovery from a dislocated shoulder and broken forearm, she joined the Doug Davis Baby Ruth Flying Circus. (Florida State Archives.)

A flight instructor at Pensacola Naval Air Station during World War I, navy Lieutenant James Albert Whitted made an historic flight from Pensacola to Cuba in an H-16 flying boat in 1919. During a flight over Pensacola Bay on August 19, 1923, a broken propeller tore the rear section off his plane. Whitted died from injuries sustained in the crash. Albert Whitted Airport in St. Petersburg was named in his honor in 1928. (Private Collection.)

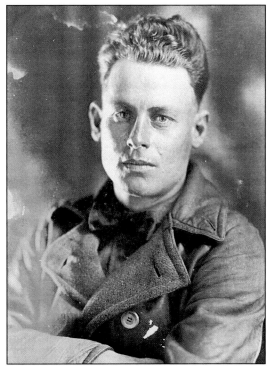

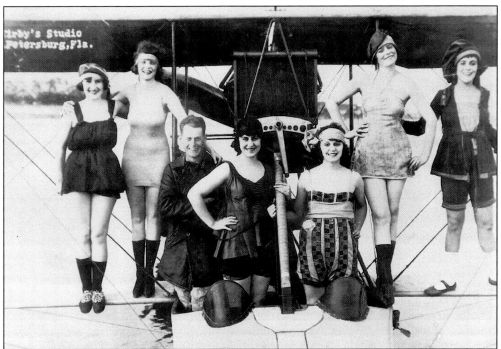

Albert Whitted built a hangar at the Vinoy yacht basin in St. Petersburg in 1919. During his civilian flying career, he safely carried several thousand passengers aboard his Curtiss flying boat. In this 1922 photograph, he poses with the Max Sennett bathing beauties in front of his flying boat *Blue Bird*. (Private Collection.)

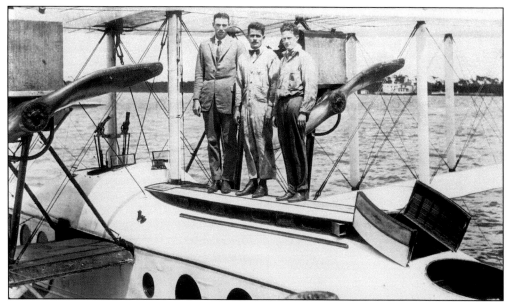

Beginning in 1921, Aeromarine Airways offered service from New York to Havana. Especially popular during prohibition, the "High-Ball" express offered two-day service to Havana, with intermediate stops at Atlantic City, Beaufort, Miami, and Key West. In less than five years of operation, Aeromarine carried over 30,000 passengers. Equipped with two luxurious passenger cabins and capable of seating 14 passengers, this Aeromarine Airways' converted Navy F5-L coastal seaplane flew between Miami and Havana in 1923. (Florida State Archives.)

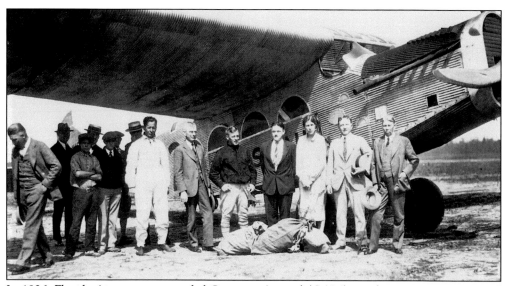

In 1926, Florida Airways was awarded Contract Airmail (CAM) number two to carry airmail from Jacksonville to Miami. On April 1, CAM number two was inaugurated, and 428 pounds of mail was loaded aboard a Ford-Stout monoplane. Present at the Tampa field was Elizabeth Barnard, postmistress of Tampa (third from right), and Perry Wall, mayor of Tampa (far right). Incorporated on November 3, 1925, the company ceased operation on December 31, 1926. (Burgert Brothers Collection, Tampa-Hillsborough County Public Library System.)

Few Florida flyers could boast a more varied flying career than "Mr. Aviation," Laurie Yonge. As did many young men, the well-known Jacksonville flyer learned to fly in a war-surplus Curtiss Jenny. During the 1920s he offered sightseeing flights, taught hundreds of students to fly, and used his Travel Aire to transport money for several Florida banks during the Depression. On May 20, 1929, Yonge set a new record for endurance flying when he piloted his airplane, *Hotsey Totsy*, over Jacksonville for 25 hours and 10 minutes. (Private Collection.)

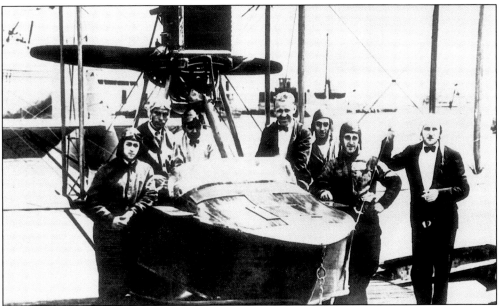

Rogers Air Line, Miami's oldest aviation company in the 1920s, boasted a fleet of eight seaplanes operating from a base near Seventh Street. Harry Rogers (seated in his Curtiss Model 18 Seagull) frequently did contract flying for Pan American Airways. On January 2, 1929, flying a Fokker F-7A, he made Pan American's inaugural mail flight from Miami to Nassau. Following the sale of his company to New York Suburban Airlines, he ran the Curtiss-Wright Flying Service at Viking Field. (Florida State Archives.)

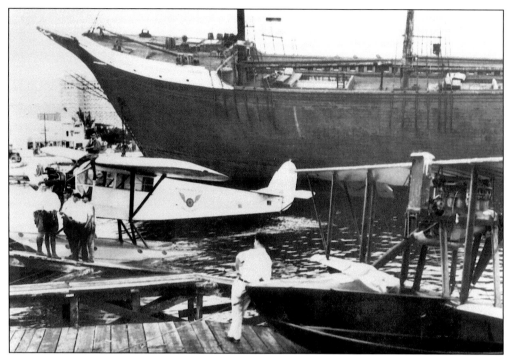

Pan American Airways ordered three Fokker F-7 trimotors to fly mail from Meacham Field, Key West, to Camp Columbia, Havana, Cuba. Under its contract, Pan American was required to begin service by October 19, 1927, or risk losing operating rights to Cuba. To meet the deadline, Pan Am chartered a Fairchild FC-2 float plane named *La Niña* from West Indian Aerial Express. Pilot Cy Caldwell departed Key West at 8:30 a.m. on October 19 with seven sacks of mail containing 30,000 letters. (Private Collection.)

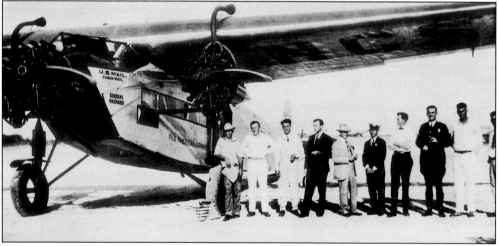

The crew poses for pictures in front of *General Machado*, named in honor of the Cuban dictator Gerardo Machado. Juan Trippe, the company's founder, is third from right. One of Pan Am's three Fokker F-7s, *General Machado* was first used to transport the mail on October 28, 1927. On a routine flight to Havana less than a year later, the plane ran out of fuel and ditched in the ocean. A nearby tanker, the SS *American Legionnaire*, rescued all but one passenger. (Florida State Archives.)

Powered by three Wright J-4 engines, the eight-passenger Fokker was capable of flying the Key West-Havana route in one hour and twenty minutes. The Fokkers were the first aircraft used by Pan American, and pioneered its passenger service on January 16, 1928. With a fuselage constructed of welded steel tubing covered with fabric or plywood skins, the Fokker F-7 boasted window views for all passengers, and a very rare offering on an airplane in the 1920s—a toilet. (Florida State Archives.)

Pan Am's passenger service from Key West to Havana was immensely popular. The company worked hard to provide passenger amenities. In 1929, Pan Am became the first airline to employ cabin attendants and serve meals aloft. At a rate of $50 one-way, more than 1,100 tickets were sold the first year. (Private Collection.)

The immigration to America of Russia's preeminent aerospace engineer, Igor I. Sikorsky, was one of the few good things to emerge from Russia's harsh Bolshevik Revolution. His contributions to the infant field of aviation proved of inestimable value. Without the contributions of Sikorsky and his various forms of amphibian aircraft, Pan American Airways would not have gone on to achieve such success in the Caribbean. (Private Collection.)

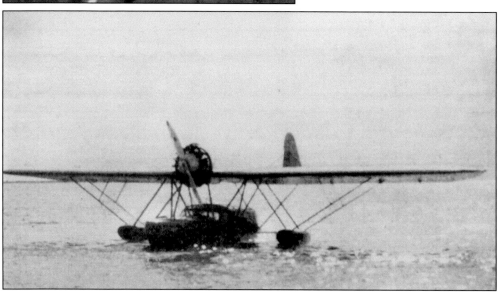

On December 7, 1927, Pan American took delivery of its first Sikorsky S-36 amphibian. Powered by a pair of Wright Whirlwind engines, the S-36 had a maximum speed of only 110 miles per hour, and a range of 200 miles. The biggest drawback of the S-36 was its difficulty in breaking free of the water on takeoff. While imperfect, the S-36 proved that an amphibian was the right aircraft for Juan Trippe's airline, at least until airports could be built in South America and the Caribbean. (Private Collection.)

As America enthusiastically embraced the future of aviation, Tampa was woefully unprepared to enter the "Golden Age of Flight." With no scheduled airline service, aviation was limited to barnstorming, plus some exhibition and private flying. The city needed an airfield to attract airlines and airmail service. This tongue-in-cheek editorial cartoon from the October 31, 1927, edition of the *Tampa Times* illustrated the community's frustration with its lack of an airport. (*Tampa Times*.)

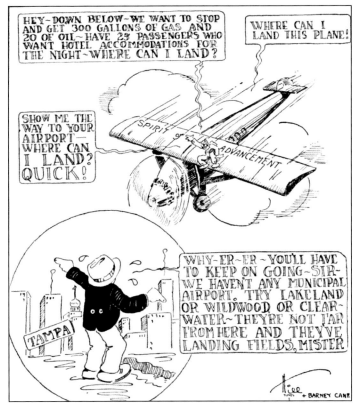

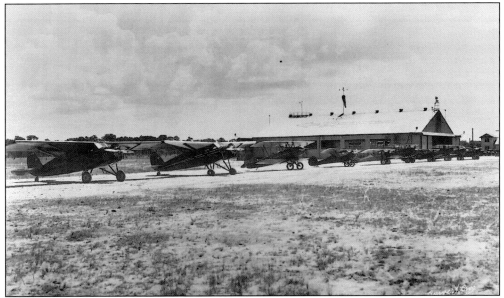

Airplanes lined the infield of Drew Field, Tampa's newly opened airport, on February 22, 1928. Approximately 50,000 people turned out for the full slate of aviation events planned for the inauguration. Hundreds of aviators flew in from around the United States to share in the festivities at Florida's newest airport, named in honor of John H. Drew, the man who had sold the county the land. (University of South Florida Special Collections.)

Clarence Chamberlin's Sperry Messenger biplane landed at Daytona Beach on February 21, 1928, en route to an air show being held in Tampa. In June 1927, less than two weeks after Lindbergh's transatlantic flight to Paris, Chamberlin in a Wright Bellanca set out from New York for Berlin, Germany. Accompanied by Charles Levine, he set a world's nonstop distance record of 3,911 miles when he landed at Eiselban, Germany. (Florida State Archives.)

In 1926, Henry Ford of the Ford Motor Company unveiled his Ford Flivver one-seat airplane that he planned to mass produce, much as he had done with the Model "T" automobile. To promote the plane, Harry Brooks flew the Flivver from Detroit, Michigan, on February 21, 1928. Traveling more than 1,000 miles at an average speed of 78 miles per hour and using only 48 gallons of gasoline, he arrived in Florida four days later. When Brooks suffered a fatal crash near Titusville Beach on February 25, Henry Ford canceled production of the Flivver. (Florida State Archives.)

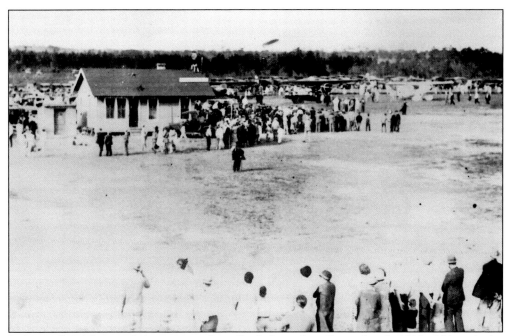

Jacksonville's Municipal Airport was formally dedicated on December 9, 1928. Although the airport had been constructed in 1927, the official opening had been delayed. When Charles Lindbergh visited the airport in October 1927, thousands turned out for just a glimpse of the first man to make a solo flight across the Atlantic Ocean. (Private Collection.)

During 1928, Pitcairn Aviation carried mail from Hadley Field, New Jersey, to Candler Field, Atlanta. By December 1, 1928, its expanded route included Miami. Airmail service to Orlando began on March 1, 1929. The Pitcairn Mailwing, a single-engine, open cockpit biplane capable of cruising at 105 miles per hour, could carry 350 pounds of mail. After Harold Pitcairn sold his company to North American Aviation on July 10, 1929, the name was changed to Eastern Air Transport. (Florida State Archives.)

Opening ceremonies at Tallahassee's Dale Mabry Municipal Airport were held on November 11, 12, and 13, 1929. The 200-acre Hamilton farm located approximately 3 miles west of the city was chosen as the site of the city's first airport, named in honor of army pilot Dale Mabry, a Tallahassee native killed on February 21, 1922, when the dirigible *Roma* crashed in Norfolk, Virginia. (Florida State Archives.)

Alexis B. McMullen leased space at Tampa's Drew Field for his flying school. In mid-1929, the McMullen Aviation School was doing a brisk business with a fleet of 11 aircraft. The school's instructors were training five pilots a month. McMullen Airways Corporation was a Travel Aire dealer, but sold or traded any kind of airplane it could. In the early 1930s, the company owned several Stinsons, a Monocoupe 90, a Bellanca, and a Great Lakes Trainer. (Tampa-Hillsborough County Public Library System.)

Five

FLORIDA TAKES
TO THE AIR

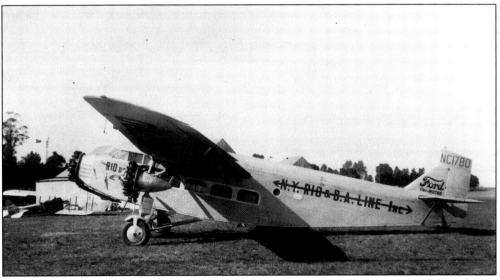

In November 1929, New York, Rio and Buenos Aires Line, known as NYRBA, began service from Miami to Rio de Janeiro, Brazil, using Ford Trimotor airplanes. Three months later, NYRBA extended the service from New York southward, along the east coast of South America, to Rio de Janeiro via Miami. When it lost its foreign airmail contract to Pan American Airways, Ralph O'Neill, the founder of NYRBA, sold his company to Juan Trippe's airline on September 15, 1930. In less than three years of operation, Pan American's route system had grown from a single route of less than 100 miles to 13,000 miles throughout the Caribbean and Central and South America. This rapid expansion was brought about through subsidiaries such as Pan American-Grace Airways (Panagra) and the acquisition of companies such as NYRBA, giving Pan Am a virtual monopoly on South American routes. (Private Collection.)

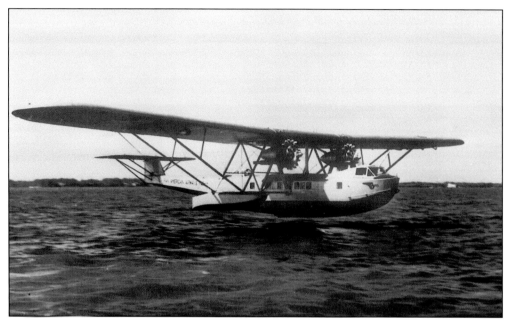

A Pan American Airways' Consolidated Commodore takes to the air over Miami in 1930. With the NYRBA merger had come 14 Consolidated Commodore flying boats. Complete with lavatories and a galley, the flying boat was capable of carrying 33 passengers. The twin-engine Commodore helped Juan Trippe to realize his objective of encompassing and controlling the Caribbean and Central and South America. (Florida State Archives.)

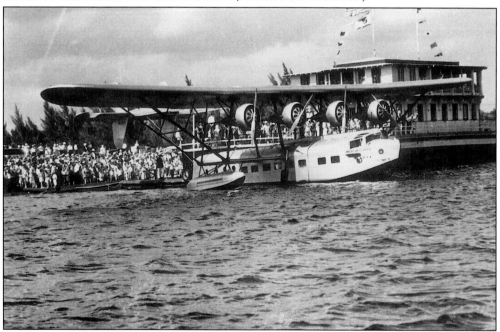

A Sikorsky S-40 seaplane was moored at the anchored barge off Dinner Key, Biscayne Bay, Miami. Pan American Airways used the floating barge before the permanent Dinner Key land terminal was constructed. Known as "a collection of spare parts, flying in formation," only three S-40s were built. (Florida State Archives.)

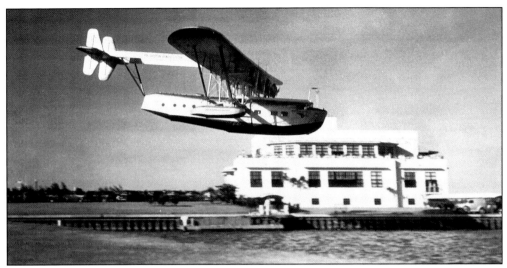

Pan Am began incorporating the four-engine S-40 flying boat into its fleet on November 19, 1931, when *American Clipper* made its inaugural passenger flight from Miami to the Panama Canal Zone. Charles Lindbergh served as pilot, with designer Igor I. Sikorsky riding as a passenger. Originally designed as an amphibian, the S-40 was used solely as a flying boat. (Florida State Archives.)

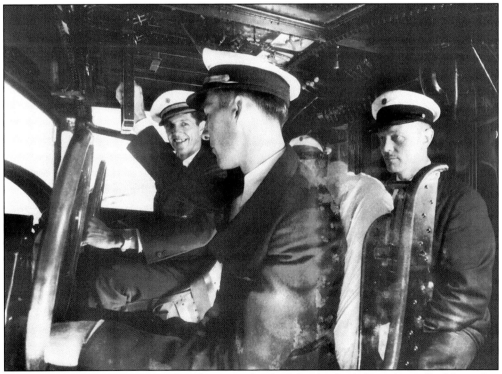

A Pan American crew is pictured at the controls of a Sikorsky S-42 flying boat. On November 30, 1932, Juan Trippe signed contracts with the Glenn L. Martin Company and the Sikorsky Aviation Company for the development of a long-range flying boat. Produced by Sikorsky, the S-42 offered a speed of over 160 miles per hour and a range of 1,200 miles. (Private Collection.)

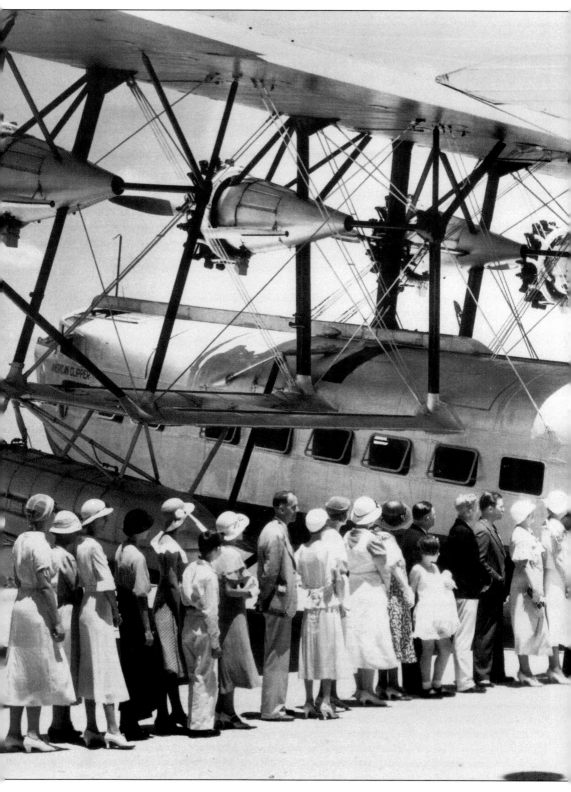

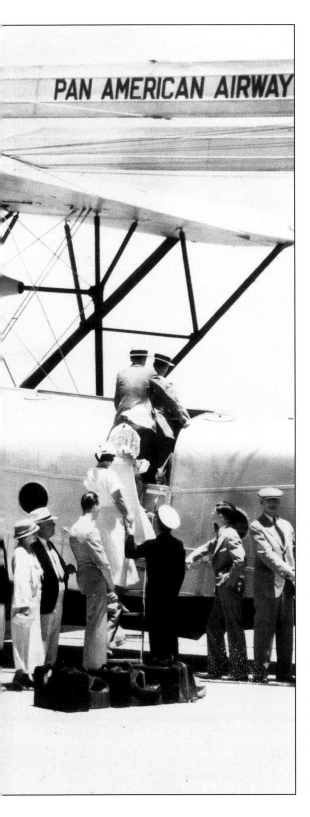

Travelers prepare to board a Sikorsky S-40 at Dinner Key, Miami. The first of Pan American's Sikorsky S-40s was christened *American Clipper* by Mrs. Herbert Hoover on October 12, 1931. This began a long tradition of naming Pan American aircraft after famous American clipper sailing ships of the 19th century. Aboard the Pan Am clipper, all was as nautical as possible. The pilot was called captain; the copilot was the first officer. Speed was reckoned in knots, and time according to bells. Like the sleek clipper ships of an earlier era, the Pan American aircraft mastered time and distance to make the world smaller and bring diverse populations ever closer together. (Private Collection.)

Pan Am relied heavily on Sikorsky aircraft in its advertising. The S-42 flying boats were described as " . . . aerial giants, whose four engines are more powerful than an average locomotive." The Sikorsky S-42 was regarded as the most beautiful aircraft of its time and was first used on Pan Am's Latin American routes. (Private Collection.)

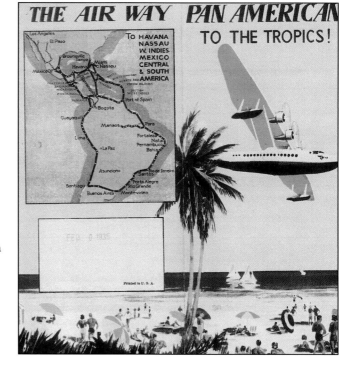

By 1934, Pan Am was flying more than 10,000 passengers annually over a route system encompassing 34,000 miles. With the implicit support of the United States government, Pan Am was providing a transportation system allowing the United States to control economic expansion throughout the tropics. Pan Am claimed to have "the largest air service in the world." (Private Collection.)

Eastern Air Transport's service in Miami in the 1930s included Ford Trimotor aircraft. Known collectively as the "Big Four," there were four major airlines in the United States in the 1930s. They included TWA, American, United, and Eastern Air Transport. Eastern was indirectly involved in the restructuring of the airmail system of the United States. In the summer of 1931, a bid was requested for airmail service from New York to Washington. Ludington Air Lines, Inc. bid on it, as did Eastern Air Transport. Eastern was awarded the contract, in spite of the fact that its bid was three times higher than that of Ludington's. When the facts were eventually uncovered, the Postmaster General of the United States called for a complete revamping of the country's airmail system in 1934. (Florida State Archives.)

Eastern Air Transport's twin-engine Curtiss-Wright Kingbird awaits passengers at Miami's 36th Street Terminal, for a flight from Miami to New York in 1931. Through service to New York was offered with stops at Charleston, South Carolina, and Raleigh, North Carolina. A one-way ticket from Miami to Newark, New Jersey, cost $74. (Florida State Archives.)

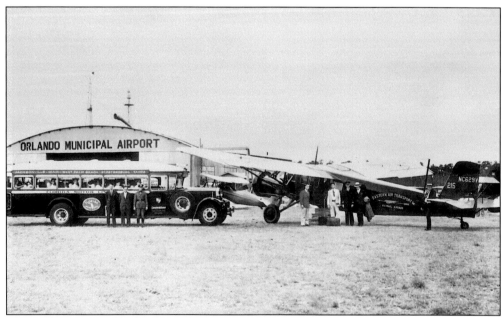

Those who governed Orlando in the early days of aviation had long been strong proponents of first-class airports. Flying in the 1920s had taken place at Buck Field. In 1928, much to the joy of several thousand attendees, the city's first municipal airport, Herndon Municipal, was dedicated. This Eastern Air Transport's Curtiss-Wright Kingbird awaits passenger boarding at the new Orlando Municipal Airport that opened on July 29, 1934. (Florida State Archives.)

Although not originally organized in Florida, Eastern Air Lines would come to be known as one of Florida's premier airlines. As did National Airlines, one of its major competitors, Eastern offered attractive airfares and tour packages as an incentive for northern visitors, who were also known as snowbirds, to fly to Florida. (Private Collection.)

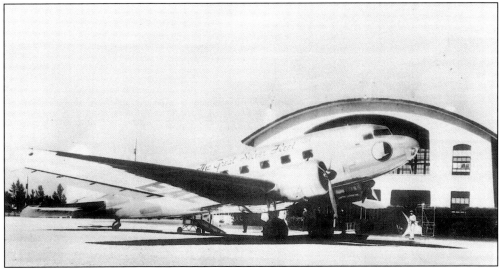

An Eastern Air Lines Douglas DC-2 is parked in front of Eastern's terminal at Thirty-sixth Street, Miami, in 1937. That same year, famed World War I ace Captain Eddie Rickenbacker purchased Eastern's "Great Silver Fleet," consisting of ten DC-2s, ten Douglas DC-3s, and two Stinson Reliant trainers, for $3.5 million. By 1941, domestic airlines in the United States had turned over one-half of their aircraft to the military. During World War II, the "Great Silver Fleet" of Eastern Air Lines became "the Great Chocolate Fleet," when its aircraft were painted army brown. (Florida State Archives.)

National Airlines Systems started operations at St. Petersburg's Albert Whitted Airport on October 15, 1934, with two secondhand Ryan monoplanes. With an airmail contract guaranteeing the equivalent of 300 pounds of mail at 17¢ per pound for a government subsidy of $51 per day, mail was the fledgling airline's lifeblood. During the first full year of operation, National carried fewer than five hundred passengers. By the time National merged with Pan American World Airways in 1980, its system had grown to an international air network of 29,000 route miles serving 12 states and 5 European countries. (Private Collection.)

Ed "Mammy" Kershaw, one of National Airlines' first pilots, posed in front of a ten-passenger Stinson in 1936. The airline's early days never lacked excitement. On one flight, almost immediately after takeoff, two male passengers got into a fist-fight. Kershaw made an emergency landing in a field near Orlando and pushed the men out of the airplane. On the ground, the fight continued until one of the men shoved the other into the aircraft, driving him through the fabric-covered fuselage. Flights had to be canceled until repairs could be made. (Private Collection.)

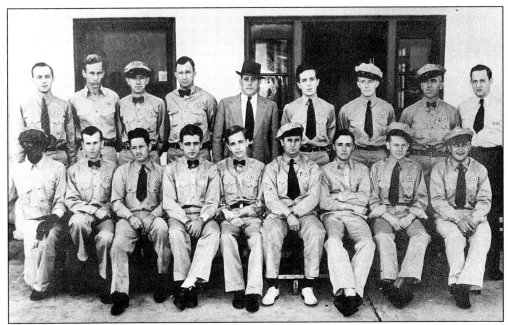

National Airlines' original employee roster included three pilots, two stenographers, and an expert mechanic. Although the number of employees gradually expanded, everyone had to work together to get the job done. One employee recalled, "My duties were varied—mechanic, cleaner, ramp agent, cargo agent, baggage man, gas and oil man, weather observer, and any other jobs that were assigned to me." (Private Collection.)

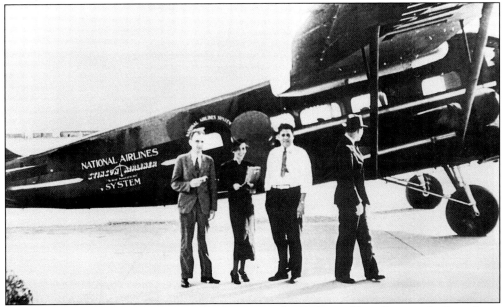

Previously employed in the cosmetics department at the Walgreen Drug Store in St. Petersburg, Charlotte Georgie (second from left) was hired as National's first flight attendant in 1935. The uniform that she wore in her new position was made for her at home by her mother. Of her duties, she recalled, "We didn't serve any food, didn't have restrooms. I used to tell passengers where we were, and pass out cigarettes, gum, and magazines." (Private Collection.)

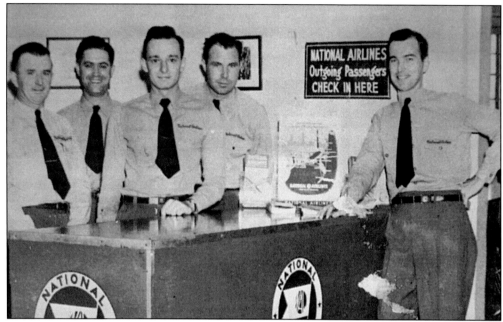

This well-staffed ticket office was the epitome of luxury compared to National Airlines' first operation in Jacksonville. There was no office. The company's part-time employee was George McColeman. Nicknamed "Sweetpea," McColeman wore dirty white coveralls emblazoned with the legend "Jacksonville Municipal Airport" in red letters on the back. He met incoming aircraft, refueled planes, and did minor maintenance. He also sold tickets, collected fares, and handed over the money to the pilots. (Private Collection.)

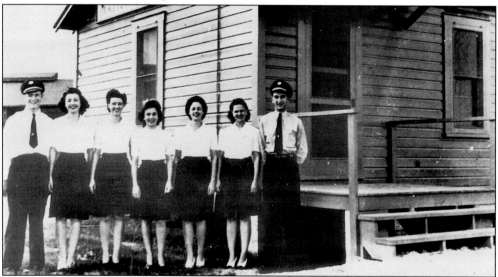

On July 8, 1937, National Airlines Systems was incorporated under the laws of the state of Florida as National Airlines, Inc. Routes were extended from St. Petersburg and Tampa to Miami, with stops at Sarasota and Fort Myers. The one-way fare from Fort Myers to Miami was $7.50. The station crew at Fort Myers included (left to right) the following: Ben Brown, Margery Franklin, Betty Huffaker, Frieda McConnell, Esther Ann Reynolds, Lessie Kitchens, and Roy Coleman. (Florida State Archives.)

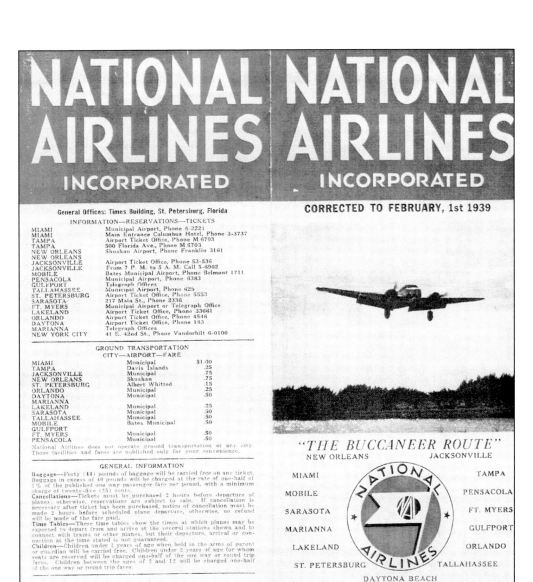

NATIONAL AIRLINES
INCORPORATED

NATIONAL AIRLINES
INCORPORATED

CORRECTED TO FEBRUARY, 1st 1939

General Offices: Times Building, St. Petersburg, Florida

INFORMATION—RESERVATIONS—TICKETS

MIAMI	Municipal Airport, Phone 8-2221
MIAMI	Main Entrance Columbus Hotel, Phone 3-3737
TAMPA	Airport Ticket Office, Phone M 6703
TAMPA	500 Florida Ave., Phone M 6703
NEW ORLEANS	Shushan Airport, Phone Franklin 3161
NEW ORLEANS	
JACKSONVILLE	Airport Ticket Office, Phone 53-536
JACKSONVILLE	From 7 P. M. to 5 A. M. Call 5-6902
MOBILE	Bates Municipal Airport, Phone Belmont 1711
PENSACOLA	Municipal Airport, Phone 6383
GULFPORT	Telegraph Offices
TALLAHASSEE	Municipal Airport, Phone 625
ST. PETERSBURG	Airport Ticket Office, Phone 5553
SARASOTA	217 Main St., Phone 2336
FT. MYERS	Municipal Airport or Telegraph Office
LAKELAND	Airport Ticket Office, Phone 33661
ORLANDO	Airport Ticket Office, Phone 4546
DAYTONA	Airport Ticket Office, Phone 183
MARIANNA	Telegraph Offices
NEW YORK CITY	41 E. 42nd St., Phone Vanderbilt 6-0100

GROUND TRANSPORTATION
CITY—AIRPORT—FARE

MIAMI	Municipal	$1.00
TAMPA	Davis Islands	.25
JACKSONVILLE	Municipal	.75
NEW ORLEANS	Shushan	.75
ST. PETERSBURG	Albert Whitted	.15
ORLANDO	Municipal	.25
DAYTONA	Municipal	.50
MARIANNA		
LAKELAND	Municipal	.25
SARASOTA	Municipal	.50
TALLAHASSEE	Municipal	.50
MOBILE	Bates Municipal	.50
GULFPORT		
FT. MYERS	Municipal	.50
PENSACOLA	Municipal	.50

National Airlines does not operate ground transportation at any city. These facilities and fares are published only for your convenience.

GENERAL INFORMATION

Baggage—Forty (40) pounds of baggage will be carried free on any ticket. Baggage in excess of 40 pounds will be charged at the rate of one-half of 1% of the published one way passenger fare per pound, with a minimum charge of twenty-five (25) cents.

Cancellations—Tickets must be purchased 2 hours before departure of planes; otherwise, reservations are subject to sale. If cancellation is necessary after ticket has been purchased, notice of cancellation must be made 2 hours before scheduled plane departure, otherwise, no refund will be made of the fare paid.

Time Tables—These time tables show the times at which planes may be expected to depart from and arrive at the several stations shown and to connect with trains or other planes, but their departure, arrival or connection at the time stated is not guaranteed.

Children—Children under 2 years of age when held in the arms of parent or guardian will be carried free. Children under 2 years of age for whom seats are reserved will be charged one-half of the one way or round trip fares. Children between the ages of 2 and 12 will be charged one-half of the one way or round trip fares.

PRINTED IN U. S. A. F-130-A

"THE BUCCANEER ROUTE"

NEW ORLEANS			JACKSONVILLE
MIAMI			TAMPA
MOBILE			PENSACOLA
SARASOTA	NATIONAL AIRLINES		FT. MYERS
MARIANNA			GULFPORT
LAKELAND			ORLANDO
ST. PETERSBURG			TALLAHASSEE
	DAYTONA BEACH		

U.S. AIRMAIL·PASSENGERS·AIR EXPRESS

George Baker, president of National Airlines, and Eddie Rickenbacker, president of Eastern Air Lines, had a long-standing rivalry. During National's first year of operation, money was in short supply and cash flow a problem. When the Gulf Oil Company delivered 50 gallons of fuel to National's St. Petersburg hangar, it informed Baker that delivery was on a C.O.D. basis. Baker felt that Rickenbacker had been behind Gulf Oil's decision. When in 1937, Baker bested Rickenbacker in a deal with the United States Postal Service, Rickenbacker was furious. Rickenbacker claimed that Baker and the people at National were nothing but pirates. Instead of taking Rickenbacker's epithet as an insult, Baker treated it as a compliment. Days later, National's aircraft were sporting a new logo—"The Buccaneer Route." (Private Collection.)

National's first route in 1934 was the 142-mile run from St. Petersburg to Daytona Beach. The trip included intermediate stops at Tampa, Lakeland, and Orlando. Local papers soon carried advertisements touting the opening of a new ticket office in downtown Tampa. In 1935, a one-way fare from Tampa to Daytona Beach was $17.27. (Private Collection.)

To meet increased demand, and to service the company's newly expanded route system, National purchased a ten-passenger Lockheed Electra 10A aircraft. It was the airline's first all-metal airplane, and the first airplane that was not secondhand; it was also the first to require a copilot. The new service was inaugurated in September 1937, with Florida's Seminole Indians participating in the ceremonies. Four L-10 Electras were eventually purchased; all bore the slogan, "The Buccaneer Route." (Private Collection.)

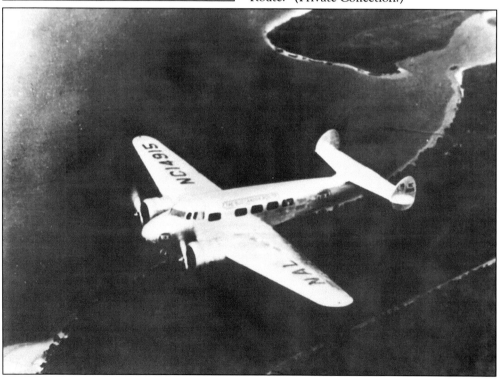

Six

THE GOLDEN
AGE OF FLIGHT

Barnstorming had become a way of life for pilots almost immediately following the Wright brothers' first flight. Daredevil feats included wing-walking, aerial transfers, parachute jumps, aerobatics, deliberate crashes, and collisions with barns. The male and female barnstormers were daring and romantic, wearing leather helmets, goggles, and silk scarves. Their wages, paid by the owners or operators of the flying circuses, were frequently a percentage of the revenue that they generated. For many young Americans, these barnstormers were their first introduction to aviation. The pilots of the Gates Flying Circus were among the premier attractions at airports and county fairs throughout the United States. Florida, with year-round good weather, attracted some of the most famous before and after World War I. Airplanes and fliers from Gates Flying Circus appeared at St. Petersburg's Grand Central Airport several times throughout the 1930s. (Private Collection.)

Lester Glasscock was a well-known Dunedin-based flier during the late 1920s and early '30s. Manager of the Florida Aircraft Corporation and Dunedin's Skyport Airport, Glasscock flew charters, performed exhibitions, and offered flight instruction. He was killed in 1934 while flying with a student pilot at the Dunedin airport, ending a 15-year flying career. (Private Collection.)

Brooksville went from no airport to two airports in less than a year. The Kiwanis Club was responsible in 1931 for the city's first airport, little more than an emergency field located on 60 acres. On opening day, several pilots performed stunt flying and offered passenger rides for $1.50. As a gesture of civic pride, Brooksville merchants provided customers with coupons, which were good toward the cost of rides. Only a few months later, a second airport opened near the Dade City Highway. (Private Collection.)

On May 28, 1931, naval reserve pilots Lieutenant Walter E. Lees and Ensign F.A. Brossy set an endurance record for sustained flying without refueling that would stand until the space age. Flying a Packard Diesel-powered Bellanca over Jacksonville, they remained aloft for 84 hours and 33 minutes. Walter E. Lees had learned to fly under the expert tutelage of Tony Jannus in 1912 at Kinloch Field and Creve Coeur Lake, Missouri. (Private Collection.)

During the winter months in the 1930s, the sight of a Goodyear blimp cruising over major Florida cities was a common sight. In September 1929, the Goodyear Tire and Rubber Company began construction of a blimp hangar at St. Petersburg's Albert Whitted Airport. The hangar was completed in December at a cost of over $30,000, and became home to one of Goodyear's blimps. The company continued to station blimps at Albert Whitted Airport until 1939. (Private Collection.)

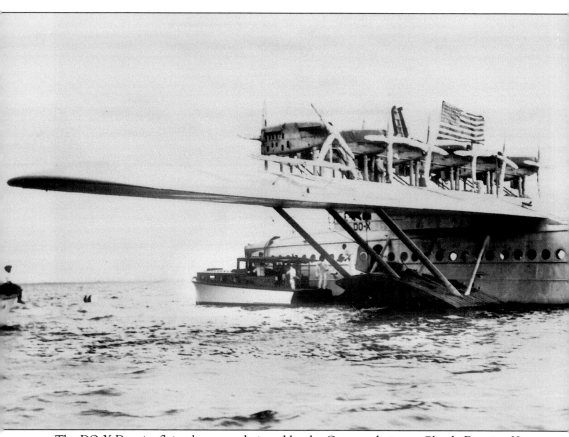

The DO-X Dornier flying boat was designed by the German designer, Claude Dornier. Known as "Dornier's Folly," the monstrous aircraft was conceived in 1926 and was capable of nonstop flights across the Atlantic Ocean. Stem-to-stern, the DO-X (DO stood for Dornier and X designated an unknown quantity) measured 131 feet in length. The wingspan was 157 feet and held 12 back-to-back Curtiss engines. The flying boat was capable of carrying 70 passengers in luxury; there were dining rooms, sleeping quarters, and a saloon. In 1931, the aircraft undertook a year-long tour with a stop at Miami on August 22, 1931. The DO-X flying boat made two transatlantic crossings and was retired to a museum in Berlin, Germany. (Florida State Archives.)

Originally opened as Venetian Causeway seaplane base in 1928, Viking Airport was located on the north side of Biscayne Island in Miami. In 1931, it was renamed Viking Field. By this time, it was used for both land and seaplanes. There was an east-to-west landing strip for land planes and moorings and ramps for seaplanes. (Florida State Archives.)

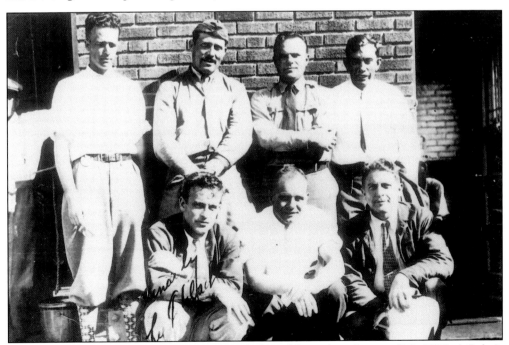

The first All-American Air Maneuvers were held in Miami from January 7-9, 1929. A "who's who" of America's most famous aviators were present, including Roscoe Turner and Jimmy Doolittle. As each January approached, "Meet me in Miami" became the rallying cry for thousands of civilian and military fliers. (Private Collection.)

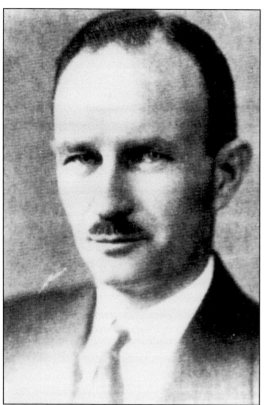

Colonel Alexis B. McMullen, the "granddaddy" of Florida aviation, was named as the first director of the aviation division of Florida's State Road Department in 1933. There were few people more qualified than McMullen; he had been a flight instructor in the army's air service and a partner in several aircraft manufacturing companies. Since the state's existing airports were anything but modern when he took over, McMullen's immediate goal was to bring about the development and modernization of aviation within the state of Florida. (Private Collection.)

In March 1933, Florida boasted 54 developed airports; three were in St. Petersburg. Grand Central Airport, located on Weedon Island, was approximately 6 miles northeast of the city. Construction on the airport began late in 1929. Through the early and mid-1930s, Eastern Air Transport used Grand Central Airport, which had three runways, a hangar, and the administration building pictured. (Private Collection.)

In the 1930s, autogyros were chartered by Miami's more elegant hotels to transport guests to and from Miami Beach. This autogyro was taking off from Miami's Bayfront Park. Invented in 1923, an autogyro is one of three types of rotor craft, along with the helicopter and gyroplane. The autogyro operates through the lift provided by a rotary wing, and the forward thrust provided by a propeller. (Private Collection.)

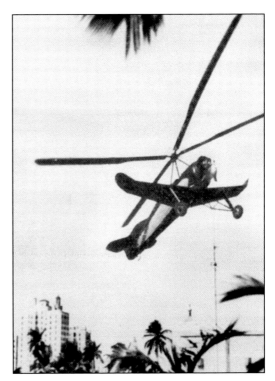

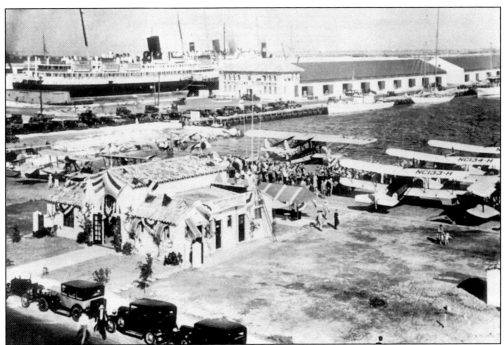

The collection of aircraft at the Miami seaplane base included Curtiss Seagulls, Sikorsky S-38 amphibians, and Loening flying boats. In 1933, Miami claimed three major airports, including the Curtiss seaplane base, the Viking land and seaplane base, and the large Pan American facility. There were also ten smaller airfields in the Miami area. (Florida State Archives.)

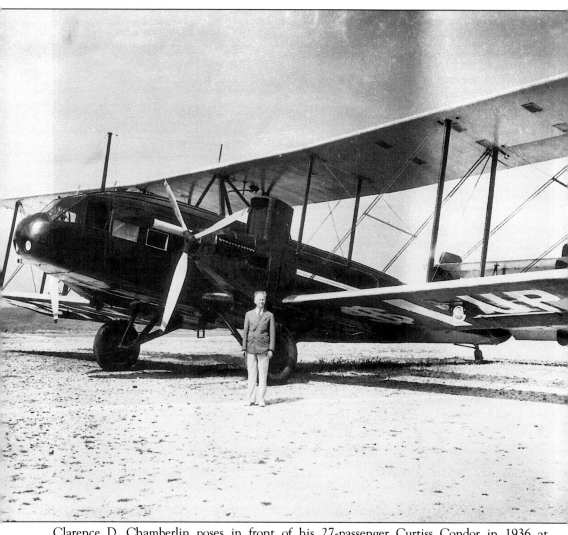

Clarence D. Chamberlin poses in front of his 27-passenger Curtiss Condor in 1936 at Albert Whitted Field in St. Petersburg. A year later, in February 1937, as part of an air tour throughout the Eastern United States, Chamberlin was in Tampa. Such trips were expensive and required financial sponsorship. In Tampa alone, Chamberlin had several sponsors, including Bamby Bread. The company claimed that Chamberlin "stresses the importance of proper physical condition at all times. Often he pilots his giant plane, the largest landship in America, for 12 to 18 hours without rest. During these periods he eats only bread and milk." The implication, of course, was that the bread was Bamby's. A decade earlier, Chamberlin had been one of the select few to conquer the Atlantic Ocean when he and Charles Levine flew from New York to Germany, a distance of 3,911 miles, in 42 hours and 31 minutes. For that feat, on November 13, 1927, Chamberlin, along with several other prominent transatlantic aviators including Charles Lindbergh, was a guest of President Calvin Coolidge at the White House. (Private Collection.)

Using his Aeronca, Otis Beard's flying service provided student instruction and passenger flights to the fearless citizens of St. Petersburg. Beard was first introduced to aviation when he watched Leonard Bonney fly at St. Petersburg in 1912. Otis later served as a pilot for the Cleveland-based Thompson Airlines. When the company went out of business, Beard returned to St. Petersburg. (Private Collection.)

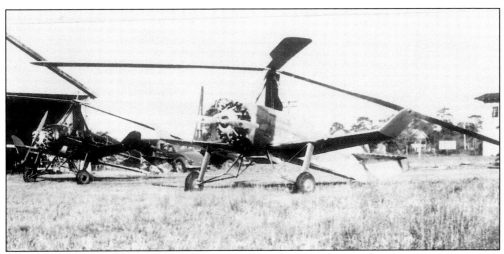

The first aerial dusting of crops took place in Florida in February 1921. It was not until 1937 that Giro Associates used rotary-winged aircraft in Sanford to dust crops. In later years, Giro Associates, owned by the Emerson brothers, Donald and Garner, also used fixed-wing aircraft to battle one of Florida's biggest problems—the mosquito. (Private Collection.)

Amelia Earhart departed Miami Municipal Airport at 5:56 a.m. on June 1, 1937, headed for San Juan, Puerto Rico, on her around-the-world flight. Almost a month later, on July 2, Earhart and her navigator disappeared forever. Earhart had frequently flown in Florida, most recently at the 7th Annual All-American Air Maneuvers in Miami, January 10-12, 1935. From 1947 until its closing in 1959, the airport was known as the Amelia Earhart Field. (Private Collection.)

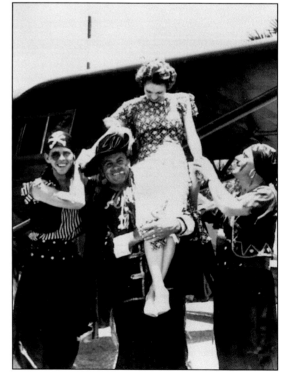

In May 1937, the aviation-minded Governor Fred Cone of Florida took the unusual action of proclaiming the week of June 21 as "Florida Aviation Week." Aviation events were planned that would grab the attention of Florida's residents and tourists. One such publicity stunt for Florida Aviation Week included the abduction of Margaret Ware, Tampa's Miss National Aeronautic Association, by "Pete the Pirate" and his crew of buccaneers. (Private Collection.)

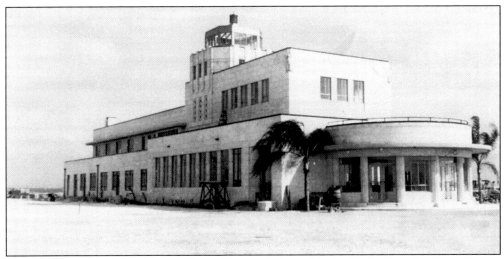

Named in honor of the St. Petersburg-Tampa Airboat Line's chief pilot, the Tony Jannus Administration Building at Peter O. Knight Airport was dedicated on November 28, 1937, and cost $100,000. Located on Davis Island in Tampa, the downtown airport originally began as a state Works Progress Administration project in 1934. Although the Tony Jannus Administration building was demolished decades later, Peter O. Knight continues to serve as an operational airport. (Private Collection.)

Judges and timers posed prior to the Mcfadden Planned Flight Contest on November 30, 1937. Wealthy publisher Bernarr Mcfadden underwrote the aviation race to encourage private flyers to come to Florida for the National Association of State Aviation Officers convention. The contest took place between Tampa and Miami, with stops at Lakeland, Orlando, Fort Pierce, and Palm Beach. An 18-inch sterling silver trophy was awarded for accuracy flying. (Private Collection.)

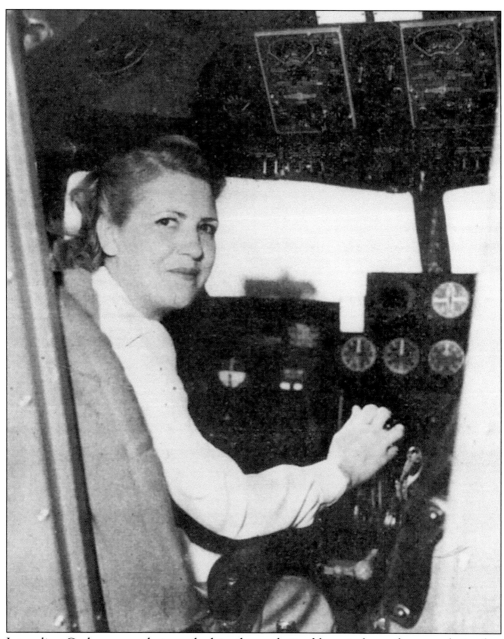

Jacqueline Cochran was photographed in the cockpit of her airplane after completing her record-setting flight from Floyd Bennett Airport, New York, to Miami in four hours and twelve minutes. Few individuals did more than Cochran to advance the cause of women in aviation. For three decades, she was unarguably one of the best-known and most-experienced female pilots. Her aviation firsts were impressive; she was an air racer, test pilot, the first woman to fly a bomber across the Atlantic Ocean, and the first woman to fly faster than the speed of sound. During World War II, Cochran was the driving force behind the Women Airforce Service Pilot program. Unsure of her birth date or where she was born (possibly 1906 in Pensacola) she didn't know how to do anything half way. She considered a barrier of any kind as " . . . only something to surmount." (Private Collection.)

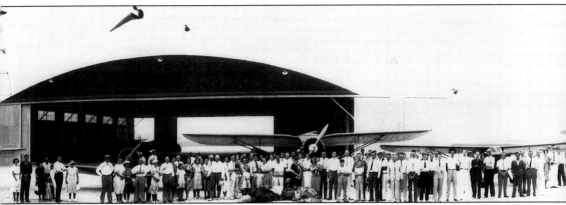

Airmail became official on May 15, 1918, when the United States Army began carrying the mail. Twenty years later, National Airmail Week was proclaimed. Pilots across America were encouraged to participate in the celebration. On May 19, 1938, nine pilots from throughout central Florida converged on Lakeland, breaking all records for the movement of airmail there. Almost two hundred pounds of letters were loaded onto a waiting National Airlines mail flight. When one of the pilots, Pete Sones of Haines City, carried his wife and infant son as passengers on the flight, the front page of one local newspaper reported, "Baby Sones Acts As Copilot, Flying Airmail With Father." Tongue-in-cheek, Sones stated that "the young man is getting to be mighty handy around a plane." (Private Collection.)

During the "Golden Age of Flight," few Floridians more avidly promoted aviation in Florida than Edgar C. Nilson. After purchasing his first airplane, a war-surplus Curtiss JN-4D, he barnstormed, gave rides, and worked at his automobile business. He also started the Bartow Airplane Corporation and organized Orlando Airlines, Inc. When the Orlando Municipal Airport opened in 1928, Nilson served without pay as manager. Orlando's "father of aviation" believed that private aviation should be "safe, sane, sensible, sound, and sanitary." (Private Collection.)

Pilots from all over the United States registered for the events at Orlando's Aerial Cavalcade in January 1939. Sponsored by Gulf Oil Company and several aircraft manufacturers, the event attracted more than four hundred airplanes. The self-proclaimed "Air Capital of Florida," Orlando touted itself as the "favorite rendezvous of private fliers." Following the activities at Orlando, most pilots flew to Miami for the All-American Air Maneuvers. (Private Collection.)

Formed by several of Florida's best-known aviators following the Second Annual Florida State Air Cruise in Miami in January 1935, the Florida Alligator Club boasted a membership of over two thousand people. To qualify for membership, pilots had to have flown a distance of at least 50 miles in Florida. The initiation ceremony required prospective members to walk blindfolded and shoeless through a pit filled with alligators that had their mouths taped shut. (Private Collection.)

Al Williams of the Gulf Oil Company strongly believed in the future of civil aviation; he pushed hard for the use of private airplanes, civil aviation, and airport development. Frequently arranging for Gulf Oil to provide free gasoline for participants, Williams was responsible for the organization of many Florida flying events. The most notable was the caravan of approximately 70 airplanes from Florida to the New York World's Fair, to celebrate "Florida Day" on June 25, 1939. (Private Collection.)

The First Annual Miami-Havana International Air Race was scheduled for December 13, 1936. Sponsors of the race included the city of Havana, the Cuban Tourist Commission, the city of Miami, and the Greater Miami Airport Association. Each contestant in the race received a red felt pennant, in addition to a pair of 14-carat gold aviator's wings embossed with the coat of arms of Havana. (Private Collection.)

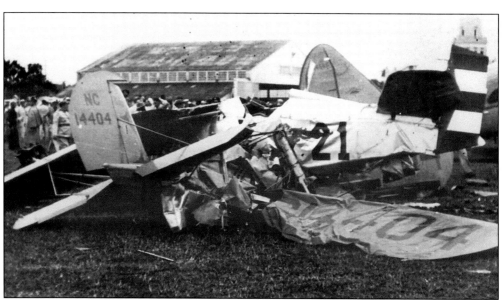

The fourth annual Miami-Havana International Air Race took place in 1939. The event included 39 airplanes and 136 participants. Unfortunately, the race was marred by a catastrophe. On Friday, January 13, there was a fatal accident in which Captain Manuel Orta, the ranking pilot of the Cuban Air Force, crashed his airplane and died. (Private Collection.)

Seven

FLYING IN THE FORTIES

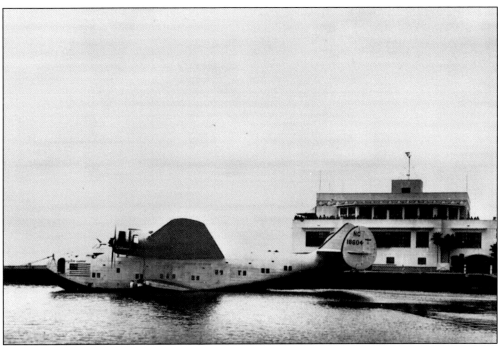

Christened *Yankee Clipper* by First Lady Eleanor Roosevelt in ceremonies on March 3, 1939, the flying boat above was photographed in Miami the following year. The Boeing 314 four-engine flying boat had been introduced to the Pan American Airways fleet for use primarily on the long transatlantic and transpacific routes. The *Yankee Clipper* pioneered transatlantic mail service on a 26-hour flight from Port Washington, New York, to Marseilles, France, on May 20, 1939. Passenger service to Europe aboard *Dixie Clipper* opened a month later. A forerunner of modern wide-body airliners, the Boeing 314 could carry 74 passengers and a crew of ten. Trained stewards saw to the needs of each passenger. A carpeted dining room seated 15 people at tables set with starched linen tablecloths and elegant china. Meals served onboard the aircraft rivaled those of some of America's finest restaurants. (Florida State Archives.)

A Piper Cub rounds a pylon during one of the races held at the Miami All-American Maneuvers in 1940. The three-day celebration, held January 4-6, drew crowds of several hundred thousand people. More than one thousand pilots flew to Miami from all over the United States for this annual aviation event. (Private Collection.)

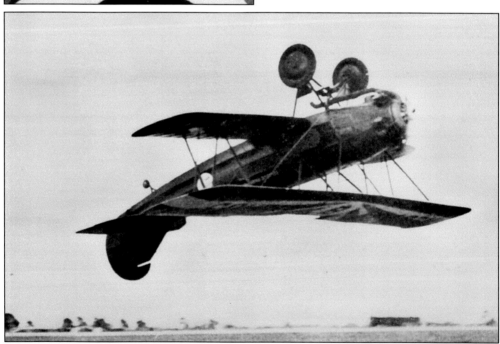

Vincent "Squeak" Burnett of College Park, Maryland, thrilled spectators when he flew his 15-year-old, green-and-black Travel Aire biplane upside down at the 12th Annual All-American Maneuvers in January 1940. The preceding year, "Squeak" Burnett had won the Freddy Lund Aerobatics Trophy at the annual air event in Miami. (Private Collection.)

George T. Baker (right) was an experienced pilot. When National Airlines took delivery of the newest airplane in its fleet, the Lockheed Lodestar, it was Baker, the airline's chief executive officer, who flew it to Florida from California. On November 2, 1940, Baker set a new coast-to-coast speed record for transport airplanes. With one stop at Dallas, Texas, Baker made the 2,357-mile flight from Burbank, California, to Jacksonville in only 9 hours, 29 minutes, and 39.5 seconds. (Private Collection.)

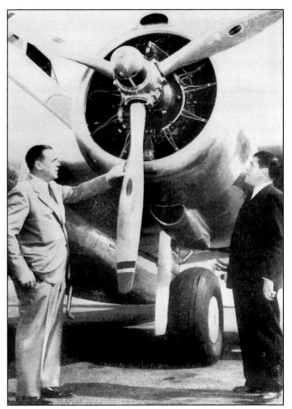

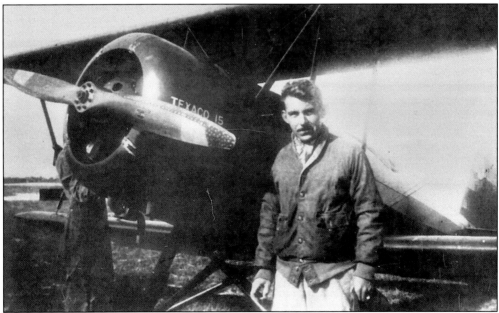

In the 1940s, Clem Whittenbeck was one of the best known of Florida's aerobatic flyers. His repertoire was almost guaranteed to thrill the thousands of people who attended air shows just to watch him fly. His performance included outside loops, outside snap rolls, and upside-down flying while only 10 feet above the ground. (Private Collection.)

Throughout the years, Florida has been home to several aircraft manufacturers, including McMullen, Babcock, Piper, and Intercontinent Aircraft Corporation. During World War II, the Defense Plant Corporation built a multimillion-dollar factory for the company near Miami Intercontinental Airport. Intercontinent was acquired by the Vultee Aircraft Company of California in 1942. Consolidated Vultee Aircraft Corporation's nine manufacturing facilities, including the Miami plant, produced approximately 11,000 airplanes in 1943. (Private Collection.)

The Babcock Aircraft Company was organized in 1939 at DeLand to produce a two-passenger, mid-wing monocoupe airplane powered by a 125-horsepower engine. When World War II ended manufacture of civil aircraft, Babcock secured an army contract for production of 50 15-passenger Waco CG-4A gliders. After receiving an order for an additional one hundred gliders, the company leased the Volusia County Fair Grounds as a manufacturing facility. The contract never proved profitable; Babcock couldn't compete with larger companies such as Ford Motor Company. (Private Collection.)

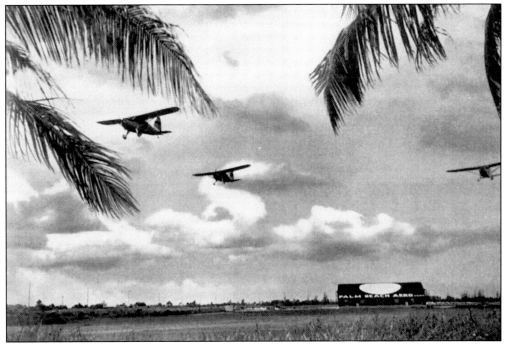

As it became evident that America would soon be involved in World War II, America's military forces realized that they were not prepared to defend thousands of miles of coastline against German submarines. The answer was the Civil Air Patrol, staffed by civilian fliers flying their own airplanes. Nationwide, Civil Air Patrol fliers flew nearly 24 million air miles, sunk two German submarines, saved innumerable downed American airmen, and were credited with the probable sinking of several German submarines. (Private Collection.)

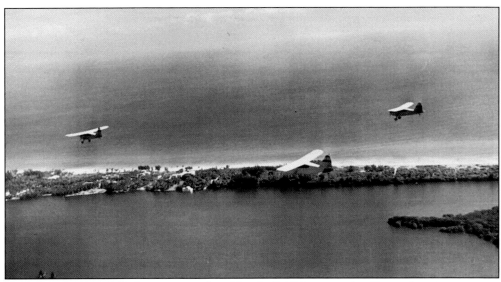

Each day several small planes assigned to Florida CAP bases took off on submarine-spotting duty. At first the privately owned single-engine Stinsons, Wacos, Beechcrafts, and Fairchilds carried no bombs or guns. Eventually, many of the CAP planes were outfitted with jury-rigged 325-pound depth charges or 100-pound demolition bombs. (Private Collection.)

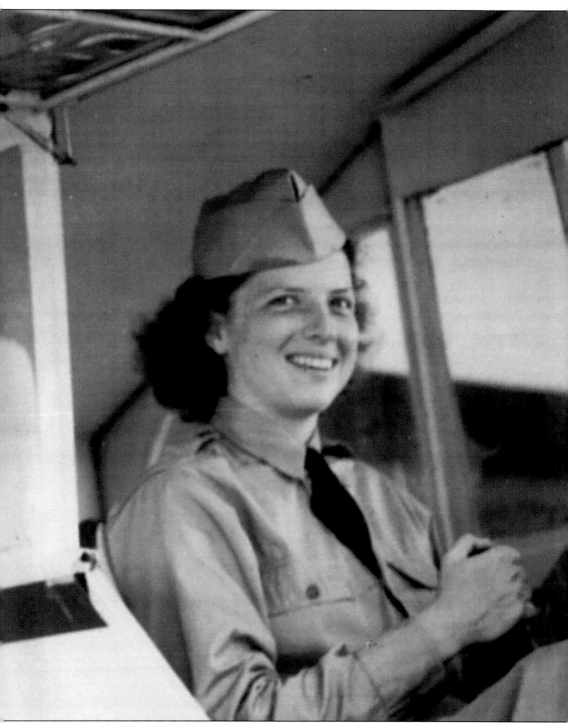

The First Air Squadron, Florida Defense Force, officially came into being on May 28, 1941, when Brigadier General Vivien Collins mustered the outfit at Morrison Field in West Palm Beach. Their mission was to "be the first unit called in case of trouble anywhere." The Civil Air Patrol began operation on December 1, 1941, and within months, CAP bases were activated

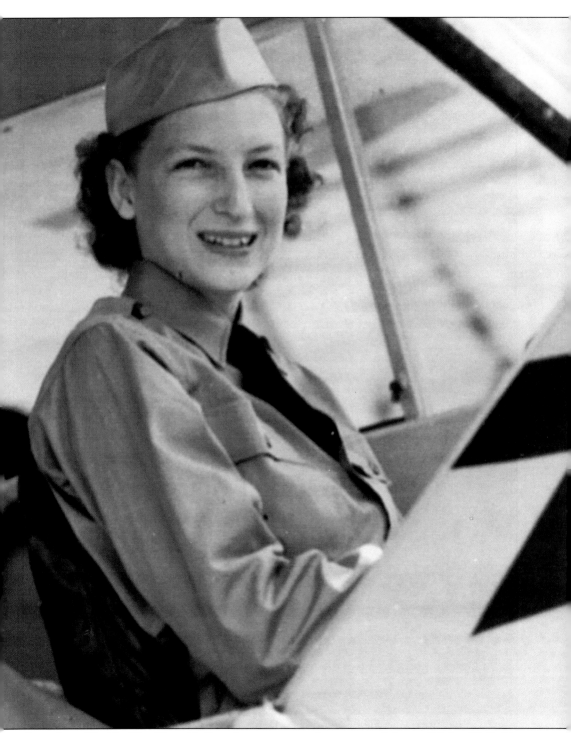

throughout Florida. The First Air Squadron encouraged women to join, as did the Civil Air Patrol. Ruth and Mary Clifford, two sisters from Lakeland with strong aviation interests, served first with Florida's Defense Force and then with the CAP, before becoming even further involved with the war effort. (Private Collection.)

Julius Lunceford Gresham, commander of Civil Air Patrol Coast Patrol Base Number Five, brought a wealth of experience to the position. A graduate of Horner Military Academy in Charlotte, North Carolina, and a Marine Corps veteran, he had served in Santo Domingo for 18 months. A Daytona Beach resident, Gresham volunteered for duty in the CAP only days before the Japanese attack on Pearl Harbor. (Private Collection.)

In October 1942, Julius Gresham opened the Civil Air Patrol Coastal Patrol Base Number Five at Flagler Beach. The new base had a pilot's lounge, a six-plane hangar, and a modern operations building. On top of the operations building was a radio shack with a pair of transmitters. (Private Collection.)

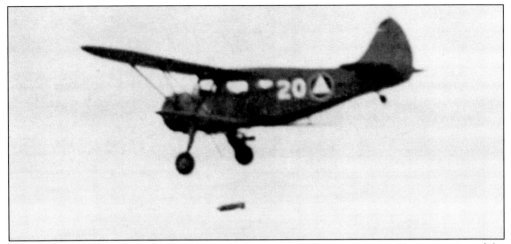

Pilot David Booher dumped his bombs in preparation for a crash landing necessitated by damaged landing gear. As accidents became a routine part of life for CAP pilots, Base Number Five suffered its share. Three aircraft were lost at sea, four were damaged in major ground accidents, and another three were damaged in minor crashes. (Private Collection.)

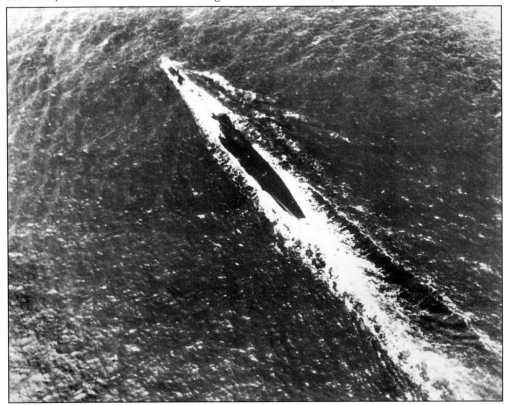

Between January and December 1942, 43 Allied tankers were destroyed on the United States eastern seaboard; nine of these were sunk off Florida. German submarines had to be stopped or the American war effort would have been greatly compromised. The job of stopping the German submarines off America's coasts fell to the small "putt-putt" airplanes of the Civil Air Patrol. (Private Collection.)

Peter J. Sones served as commander of CAP Coastal Patrol Station Number 13 at Sarasota. He received the Exceptional Civilian Service Medal for his service. While Sones was away on active duty, his wife was doing her part for the war effort back home in Haines City. As a member of the local civil defense observation team, Eleanor Sones spent many hours on the roof of the Hotel Polk scanning the skies for enemy aircraft. (Private Collection.)

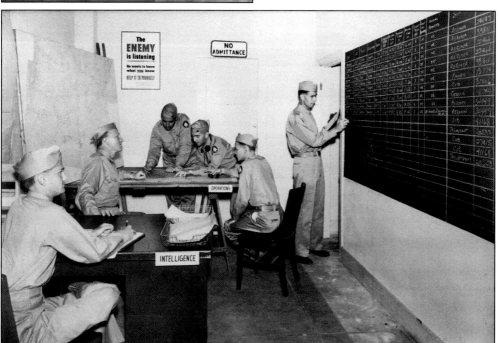

Civil Air Patrol intelligence officers at Daytona Beach plotted out the day's flying activity against German submarine or "pigboat" activity. Men and women came from all over Florida and throughout the United States to serve in the Daytona Beach CAP. Ultimately, a total of 39 airplanes were assigned to the base. Accidents were a routine part of daily life; three aircraft were lost at sea. (Private Collection.)

In the early days of aviation, women were largely excluded from either flying or ground positions. World War II changed that. With a shortage of manpower, many occupations formerly closed to women, such as those of aircraft mechanics and aircraft factory workers, now were opened. With the end of the war and soldiers returning to the civilian work force, for the most part, women were again relegated to the sidelines. (Private Collection.)

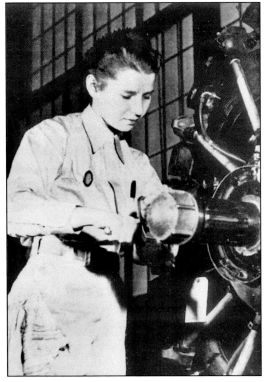

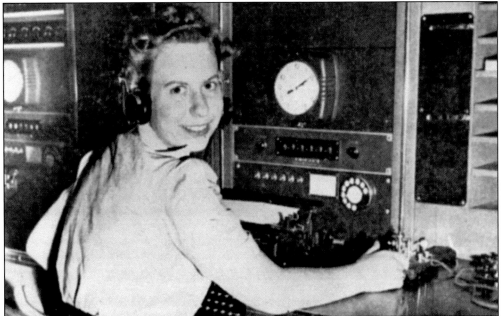

Some women have had a role in American aviation since the beginning, however their story has seldom been told. Anne Kathryn Porter worked for Eastern Air Lines at Miami. At the age of 19, Porter became a licensed radio telephone operator. Three months after graduation, she joined Eastern Air Lines as a radio operator. During World War II, Porter served in the United States Army in the radio engineering department. (Private Collection.)

A 1946 newspaper advertisement promoted National Airlines New York-to-Havana service, which included a stop in Tampa. For many years, Cuba was a popular vacation destination of American tourists seeking tropical sun and recreation. The coup d'état by Fidel Castro ultimately led to the cancellation of airline service to the island. (Private Collection.)

Following World War II, the All-American Air Maneuvers resumed at Miami in 1946. The next year, women fliers were told that they could not take part. Unwilling to be excluded, the women organized their own fly-in at Tampa's Peter O. Knight Airport. The 99s All-Woman Air Show was held on March 15 and 16, 1947. One participant declared that it " . . . will truly be a memorable event, and should make a name for Tampa in aviation." (Private Collection.)

Eight

WAR

Florida did its part for the war effort. During World War II, few areas of Florida did not boast at least one military base, as represented by these cards. Pilots, mechanics, gunners, and hundreds of thousands of support personnel had to be trained. Civilian Pilot Training Programs were offered at many Florida schools, including the University of Miami, Rollins College, Florida Southern College, Embry-Riddle, and the University of Florida. Private aviation training facilities such as Avon Park's Lodwick Aviation Military Academy and Ocala's Greenville Aviation School provided flight training for aviation cadets. Previously existing Air Corps fields grew by leaps and bounds. Newly commissioned Air Corps, Navy, and Coast Guard fields seemed to come from nowhere. Additional air bases had to be constructed. Tampa's MacDill Field became one of the largest. Airlines such as National, Eastern, and Pan Am were called upon to do their part, setting up military training facilities, both ground and air. Airline pilots ferried military aircraft from the United States to Europe. To provide badly needed transport aircraft, many of the airlines' planes were turned over to the military. (Private Collection.)

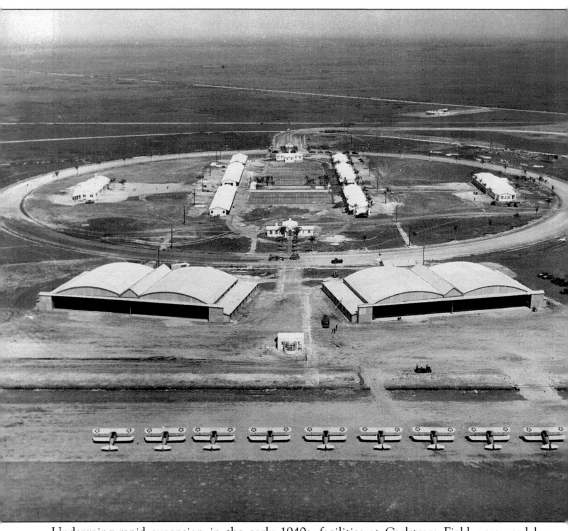

Undergoing rapid expansion in the early 1940s, facilities at Carlstrom Field were used by Embry-Riddle Aero Institute from April until August of 1941. During World War II, Carlstrom Field was used to train 7,145 aviation cadets. The large flat, treeless prairie outside Arcadia was perfect for flight instruction. By the time Carlstrom Field closed in November 1945, cadets had logged 525,636 hours of flight and 45 million air miles with only one fatality. Embry-Riddle employed both men and women to train cadets. Helen Cavis, a 27-year-old Washington society girl, worked for the Embry-Riddle School of Aviation as one of America's few female flight instructors, and was named chief of the women's flying division. (Embry-Riddle Aeronautical University.)

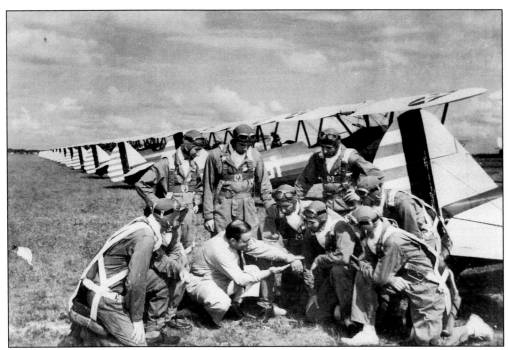

A fleet of Stearman training biplanes are lined up in readiness on the Carlstrom Field flight line in the early 1940s. Army Air Corps cadets received a preflight briefing from their Embry-Riddle civilian flight instructors before taking off to practice aerial maneuvers in the skies over central Florida. Sufficient training at home, it was hoped, would enable the pilots to survive the rigors of aerial combat in Europe. (Embry-Riddle Aeronautical University.)

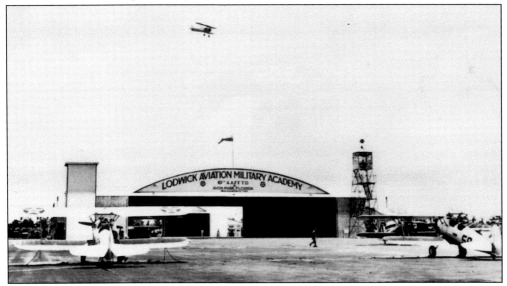

During World War II, there were not enough military facilities to train pilots. When flight-training programs were quickly established at civilian schools, two of the most successful were owned and operated by Albert I. Lodwick. Both Lodwick Aviation Military Academy at Avon Park and Lodwick School of Aeronautics at Lakeland were used to provide training to United States Army flight cadets. British cadets also trained at both facilities. (*Lakeland Ledger.*)

During World War II, British Royal Air Force flight students were sent to the United States for flight training with American cadets at several Florida airfields. Royal Air Force cadets studied navigation and meteorology in Miami. The University of Miami was used for dormitories, cafeterias, and classrooms. In-flight training took place on Pan American Airways planes. At many of the bases, including Arcadia's Dorr Field, American and British flight cadets trained side by side. Intensive wartime instruction resulted in a number of fatalities. Twenty-five RAF cadets died during training and were buried at Arcadia's Oak Ridge Cemetery. (Florida State Archives.)

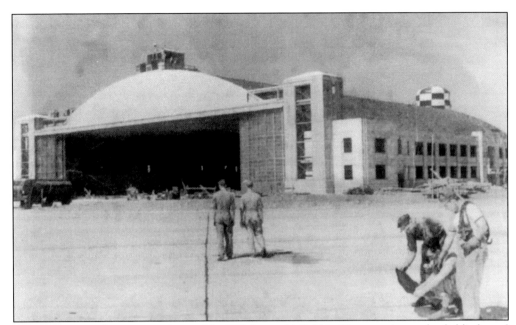

A hangar was under construction at MacDill Army Airfield in Tampa prior to the field's formal dedication on April 15, 1941. Named in honor of Army pilot Colonel Leslie MacDill, who was killed in a plane crash near Washington, D.C., on November 9, 1938, the base served as the home of the Third Bomber Command. Crews were trained on several types of heavy aircraft, including B-17, B-25, B-26, and B-29 bombers. (Tampa-Hillsborough County Public Library.)

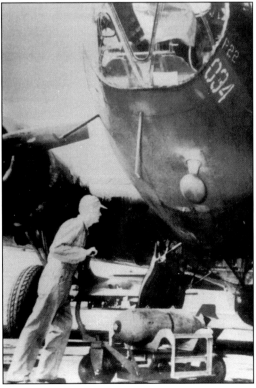

Armorers loaded bombs onboard a B-17 Flying Fortress at MacDill prior to a practice bombing mission over the Gulf of Mexico. Flight accidents, generally involving the B-26 Martin Marauder, became almost commonplace at MacDill. Although not accurate, civilians and military personnel alike began referring to the accidents as "One a day in Tampa Bay." (Tampa-Hillsborough County Public Library.)

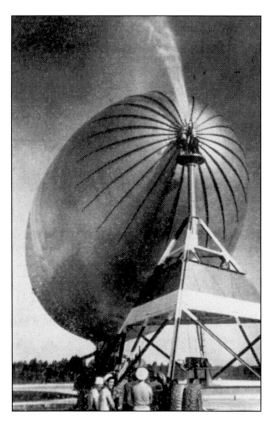

Non-rigid airship K-type blimps on ship escort convoy duty patrolled the Atlantic Ocean off the Florida coastline. Made by Goodyear, the blimps were powered by Pratt & Whitney Wasp engines. Stationed at Richmond Naval Air Station, 20 miles southwest of Miami, the blimps made daily anti-submarine patrols. Ship convoy duty was dangerous; the blimps provided a fat, slow-moving target for German submarine gunners. (Private Collection.)

The United States Navy took control of most Florida blimp bases in 1942. In March 1943, Air Ship Group 2 was formed at Richmond and received its first blimp, K-44. At the height of World War II, six blimps were housed in three giant blimp hangars at the Richmond Naval Air Station. The base's three large blimp hangars were destroyed by a hurricane in September 1945. (United States Navy.)

Overhaul facilities were established for blimps operating in the southeastern United States as part of Allied ship convoy protection during World War II. At Richmond Naval Air Station, maintenance mechanics performed routine engine changes on the giant K-blimps out-of-doors. Each Pratt & Whitney AN-2 aircraft engine weighed close to 1,000 pounds. (Private Collection.)

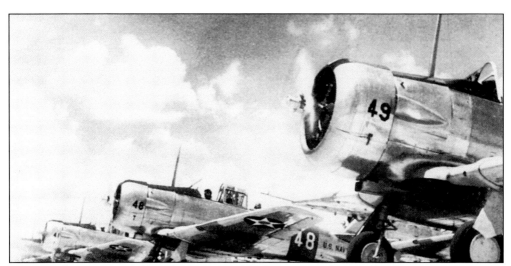

Pratt & Whitney-powered North American AT-6 trainers, redesigned by the navy as the SN53, lined up on the flight line at Jacksonville Naval Air Station. The base, originally commissioned in October 1940, grew by leaps and bounds during World War II. At the height of the war, over 30,000 civilian and military personnel were assigned to the sprawling 3,000-acre Jacksonville Naval Air Station. (Private Collection.)

General James H. Doolittle's accomplishments in the field of aviation are legendary. He was an air racer, World War I pilot, and record breaker. On September 4, 1922, he made a single-stop flight from Jacksonville to San Diego, California, in only 21 hours and 18 minutes. Doolittle held degrees in aeronautics from Massachusetts Institute of Technology and pioneered in instrument flying. Despite all of his achievements, however, he is best known as the commander of Doolittle's Raiders, a volunteer group of B-25 bomber pilots that led a daring and historic aircraft carrier-based raid against Tokyo during World War II. Doolittle's Raiders trained at Florida's Eglin Army Airfield near Panama City. (Private Collection.)

"Let's go! U.S.A. Keep 'em flying!" During World War II, Florida offered as much assistance toward the training of pilots as any other state. From the north to the south to the east to the west, military pilots were trained in Florida. Women, as well as men, were used to train flight cadets. (Private Collection.)

UNCLE SAM NEEDS PILOTS
BE A U. S. ARMY
FLYING CADET

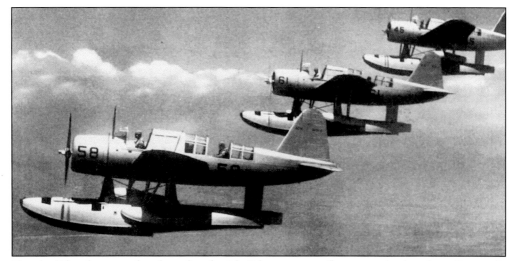

Vought-Sikorsky scout bombers fitted with Edo pontoons flew over the beach at Pensacola Naval Air Station. Powered by a 425-horsepower, air-cooled, supercharged radial Wasp engine, the bomber resulted from an amalgamation of several manufacturers. Vought Aircraft had a long-standing relationship with the United States Navy. The Sikorsky Aviation Corporation was unparalleled in the design and construction of flying boats. Edo Aircraft Corporation manufactured the floats. (Private Collection.)

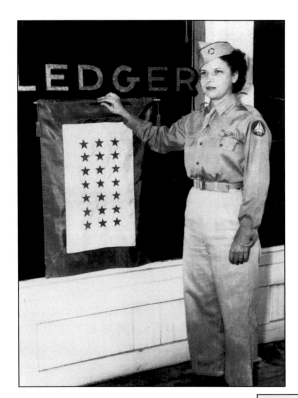

Ruth Clifford, a member of the Civil Air Patrol, poses outside the offices of the *Lakeland Ledger*. Each star on the banner in the window represented a *Ledger* employee serving in the military. In 1939, the Haldeman Flying Service offered a prize for the best aerial photograph of Lakeland. To get the photographs needed for the contest, Clifford hired a pilot to take her flying. While she didn't win the prize, her lifelong love of flying was born. (Private Collection.)

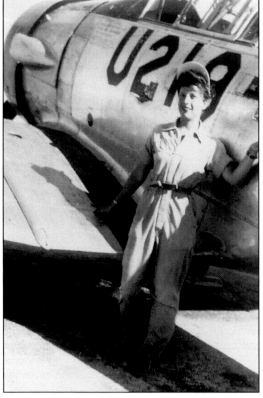

By the time Ruth Clifford entered the Women Airforce Service Pilots training program in March 1944, she had almost 450 hours of flying experience recorded in her logbook. Unlike most of her fellow classmates, she also held a commercial pilot's license with an instructor rating. Ruth Clifford graduated as a member of the 16th class of WASPs on October 9, 1944. (Private Collection.)

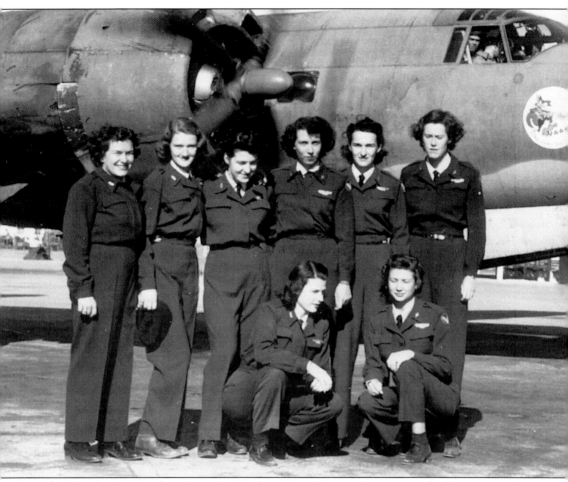

Dorothy Ebersbach learned to fly in the Civilian Pilot Training Program at the University of Tampa in 1939. Already a member of the Civil Air Patrol, she was eager to serve her country during time of war, and applied to both the navy and the Army Air Corps in 1942. Described as Tampa's only WASP, Dorothy Ebersbach (standing left) became a member of the fifth class of trainees to go through the Women Airforce Service Pilots program. Following training, she was assigned to duty as a utility pilot. Her jobs included test-flying airplanes following maintenance and repair work, as well as flying B-25s while towing targets for gunnery practice. The Women Airforce Service Pilots performed magnificently, logging more than 60 million miles during their service to their country before the program was deactivated on December 20, 1944. Many were stationed at various locations in Florida, including Orlando and Fort Myers. (Private Collection.)

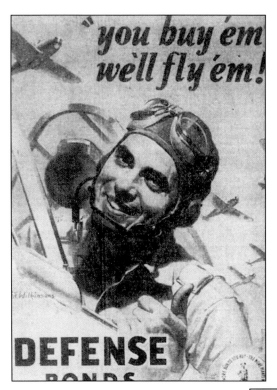

Complete with patriotic artwork and catchy slogans, war bond and recruiting posters were produced by the millions. Their message was clear—America needed money to buy airplanes and men to fly them. What was equally clear, however, was that the War Department wanted only white males as pilots. Women and African Americans waged a long struggle to become part of the Army Air Corps. When finally allowed to serve their country as pilots, they proved that they had what was needed. (Private Collection.)

During World War II, the War Department assigned African Americans to aviation squadrons in which personnel were assigned jobs such as stevedores, truck drivers, and guards at airfields. Although the Tuskegee Airmen were the first African Americans to serve as pilots in the United States military, most blacks were restricted to menial work. (Tampa-Hillsborough County Public Library.)

Charles P. Bailey, born in Punta Gorda, graduated from the single-engine pilot training program at Tuskegee Army Air Field on April 29, 1943. During his European service, he flew 133 combat missions in two different aircraft, *My Buddy* and *Josephine*, named in honor of his parents. On May 29, 1945, Charles Bailey, a Tuskegee Airman, was awarded the Distinguished Flying Cross for " . . . extraordinary achievement while participating in aerial flight in the Mediterranean Theater of Operations." (Private Collection.)

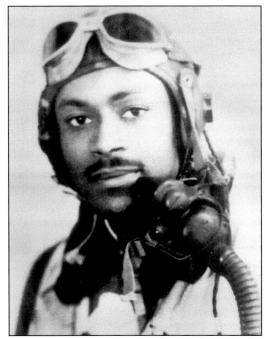

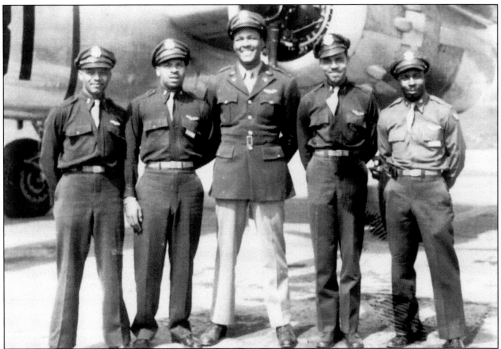

Daniel "Chappie" James Jr. was born in Pensacola in 1920. A member of the famed Tuskegee Airmen during World War II, James also flew 101 combat missions during the Korean War. As vice commander of a tactical fighter wing in Thailand, he flew 78 combat missions over North Vietnam. On August 29, 1975, Daniel James Jr. became the United States Air Force's first African-American four-star general. On July 24, 1993, Daniel "Chappie" James Jr. was enshrined in the National Aviation Hall of Fame. (Private Collection.)

A flight of naval training planes flew over Pensacola Naval Air Station. Following World War I, the number of naval aviators trained at Pensacola decreased greatly. The 12-month flight training program graduated approximately one hundred pilots annually. Most of the men going through the program were Annapolis graduates, hence Pensacola Naval Air Station became known as the Annapolis of the air. When the cadet program was inaugurated in 1935, the number of cadets trained increased slightly. Prior to America's entry into World War II, subsidiary or auxiliary training bases were constructed at Pensacola; these included Saufley, Ellyson, Bronson, and Whiting Fields. When the United States entered World War II, the state of naval aviation was woefully inadequate. Following the Japanese attack on Pearl Harbor, Pensacola Naval Air Station grew at a frenzied pace, training as many flyers as possible. (United States Navy.)

Nine

SPACE

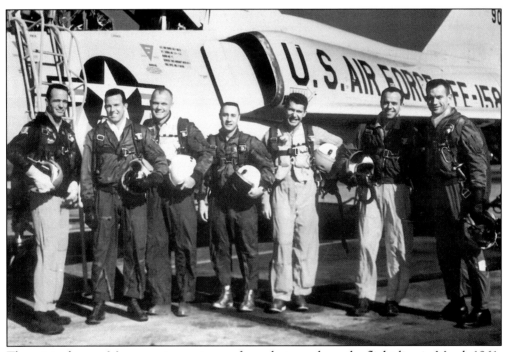

The original seven Mercury astronauts pose for a photograph on the flight line in March 1961. From left to right are M. Scott Carpenter, L. Gordon Cooper Jr., John H. Glenn Jr., Virgil I. Grissom, Walter M. Schirra Jr., Alan B. Shepard Jr., and Donald K. "Deke" Slayton. The United States intended the Mercury project as a means to overcome the Soviet Union's clear superiority in space exploration. NASA's plan was to launch one of these men, the select seven, into space in a Mercury capsule in 1960. It didn't happen until a year later. On May 5, 1961, United States Navy Commander Alan Shepard climbed into the *Freedom 7* capsule. At 9:34 a.m., the 80-foot-high Redstone rocket lifted off the launch pad at Florida's Cape Canaveral. The first American had been sent into space; the other six astronauts would all eventually get their turn to fly in space as well. (National Aeronautics and Space Administration.)

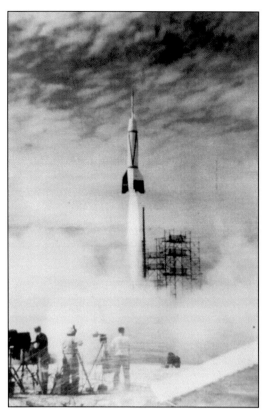

Florida entered the space age with the launch of a V-2/WAC Corporal from Cape Canaveral on July 24, 1950. Manufactured from parts of a captured World War II German V-2 rocket, the WAC Corporal was affixed to the V-2, producing a two-stage vehicle. Florida's appeal as a launch site for space vehicles was obvious; miles of open seas off Florida's coast provided a wide-open launch and recovery area. (National Aeronautics and Space Administration.)

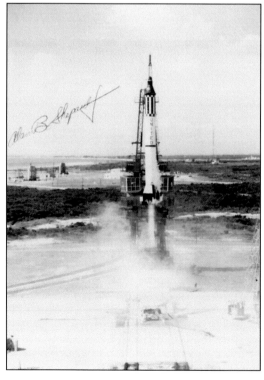

"Ignition. Mainstage. Liftoff," came the announcer's voice at Cape Canaveral on May 5, 1961. At 9:34 a.m., Alan B. Shepard Jr. was launched from Cape Canaveral's pad five, onboard space capsule *Freedom 7* atop a Mercury Redstone 3 rocket. America had launched its first astronaut into a manned sub-orbital flight. One of the seven original American astronauts, Shepard, a veteran navy flier, was in flight for 15 minutes and 22 seconds, and reached an altitude of 116 miles. (National Aeronautics and Space Administration.)

John H. Glenn Jr. took America into the business of manned space flight on February 20, 1962. Launched from an Atlas missile, John Glenn, in *Friendship 7*, lifted off the launch pad at Cape Canaveral at 9:47 a.m. Becoming the first American to orbit the Earth, Glenn traveled more than 81,600 miles before the mission ended. Less than five hours after launch, Glenn splashed down near Grand Turk Island, Bahamas, in the Atlantic Ocean. (National Aeronautics and Space Administration.)

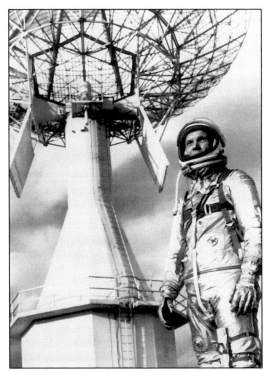

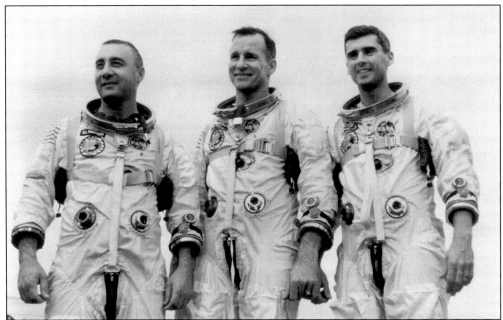

Apollo 1 astronauts Virgil I. Grissom, Edward H. White II, and Roger B. Chaffee were photographed in their space suits at the Kennedy Space Center on December 12, 1966. Scheduled for February 21, 1967, their launch would never take place. January 27, 1967, was one of the worst days in the history of America's space program. Grissom, White, and Chaffee died when an electrical short aboard the space capsule resulted in a fire and explosion. (National Aeronautics and Space Administration.)

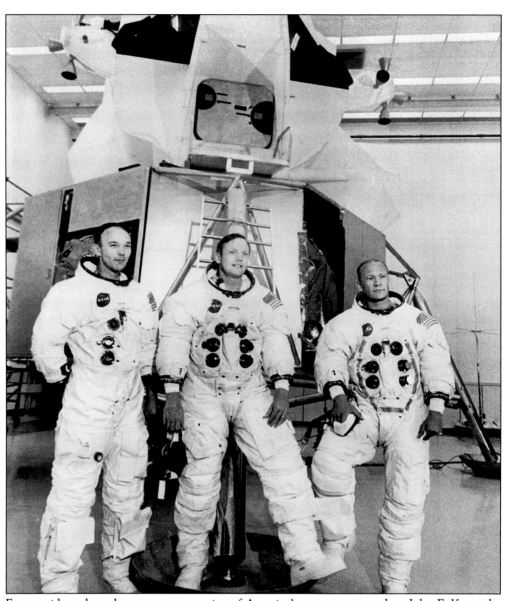

Few presidents have been more supportive of America's space program than John F. Kennedy. He clearly voiced his support and objectives in a May 25, 1961 speech when he declared, "I believe that this nation should commit itself to achieving the goal, before this decade is out, of landing a man on the moon and returning him safely to earth." On July 16, 1969, Apollo 11 lifted off a launch pad at Cape Canaveral's Kennedy Space Center. Its destination was the Moon. In the capsule were Neil Armstrong, Edwin "Buzz" Aldrin, and Michael Collins. Four days later, on July 20, hundreds of millions of people watched their televisions in anticipation of what was about to happen. As Armstrong stepped from the lunar module *Eagle* to become the first man to walk on the Moon, few will ever forget his comment, "That's one small step for man, one giant leap for mankind." Aldrin soon followed him, while Michael Collins remained in orbit. The three Americans ended their eight-day mission and returned to Earth on July 24, 1969. Just eight years after President Kennedy's speech, the *Eagle* had landed. (National Aeronautics and Space Administration.)

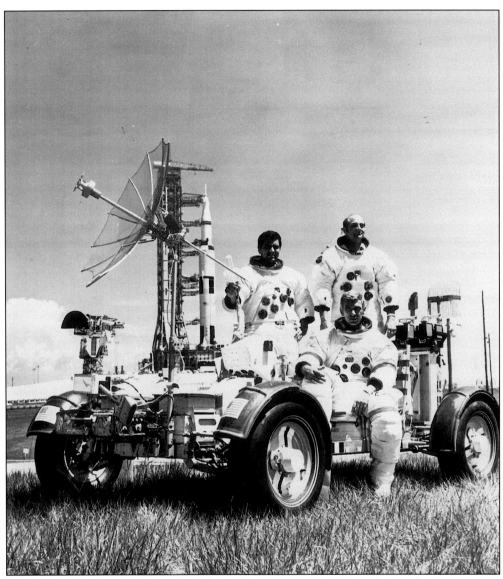

Apollo 17 astronauts Harrison H. Schmitt, Ronald E. Evans, and Eugene A. Cernan were photographed aboard their lunar rover at the Kennedy Space Center. Scheduled for December 6, 1972, Apollo 17 would be America's last mission to the Moon. Cernan was the 11th man on the Moon; Schmitt was the 12th. A million spectators turned out at Cape Canaveral to witness the first night launch of an Apollo mission. Launch was delayed by a two-and-a-half-hour hold. At 12:33 a.m., the Saturn V lifted off the launch pad at Complex 39A. *America,* the command module that would orbit the Moon, was piloted by Evans. Onboard the lunar module, *Challenger,* Schmitt and Cernan landed on the Moon at 2:54 p.m. Cernan exclaimed, "We is here. Man, we is here." The two astronauts spent a record 75 hours on the Moon, conducted numerous experiments, collected hundreds of pounds of rocks, and even suffered a fender bender with their lunar rover. They splashed down into the Pacific Ocean on December 19. The last American flag had been planted on lunar soil; an era had ended. (National Aeronautics and Space Administration.)

Many people, including civilian contractors, military personnel, and NASA employees, are required to ensure the successful launch and return of American astronauts. Thousands of these vital support personnel at the Kennedy Space Center turned out to greet returning Gemini 12 astronauts James A. Lovell Jr. and Edwin "Buzz" Aldrin Jr. Their mission had been to dock in space with a target Agena rocket launched just minutes before their own takeoff. The November 11, 1966, flight marked NASA's final two-man mission. In recognition of that fact, Lovell and Aldrin attempted a note of humor as they rode the elevator toward their capsule. Each wore a hand-lettered sign taped to his back. Lovell's read "The" and Aldrin's "End." After 59 Earth orbits, Gemini 12 returned to Earth on November 15. Aldrin had worked outside the capsule for a record-setting five and a half hours. With his second Gemini mission, Lovell entered the record books with 425 hours and 10 minutes in space. (National Aeronautics and Space Administration.)

The astronauts of Skylab 2, Commander Charles Conrad Jr., Dr. Joseph Kerwin, and Paul Weitz, pose in front of the Saturn IB rocket that would launch them into space on May 25, 1973. Designed as a four-mission program, Skylab was intended to test how well astronauts could cope mentally and physically with long periods in space. After spending 28 days in space, they returned to Earth on June 22 where they were picked up by the USS *Ticonderoga* in the Pacific Ocean. (National Aeronautics and Space Administration.)

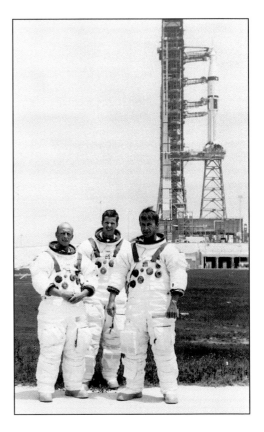

The Russo-American crew of the Apollo-Soyuz Test Project included: (standing left to right) Apollo commander Tom Stafford and Soyuz commander Aleksei Leonov; (seated left to right) Deke Slayton, Vance Brand, and Valeri Kubasov. The objective of the project was the successful docking of American and Russian vehicles in space. Soyuz 19 was launched on July 15, 1975, from Russia; Apollo was launched from the Kennedy Space Center almost eight hours later. On July 17, Apollo and Soyuz successfully met and remained docked in space for nearly two days. (National Aeronautics and Space Administration.)

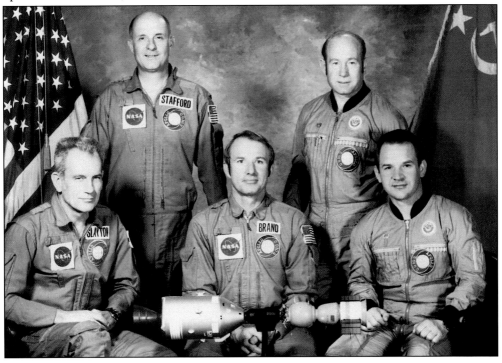

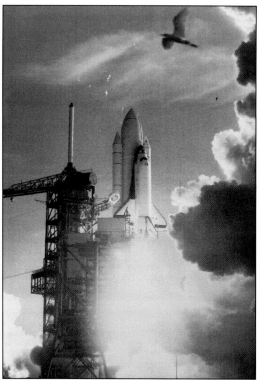

Space transportation system STS *Columbia*, the first of America's space shuttles, was launched from Cape Canaveral's Kennedy Space Center on April 12, 1981. John W. Young, a veteran of the Gemini and Apollo programs, was joined by Robert L. Crippen on the *Columbia* mission. After spending 50 hours in space, *Columbia*, the first reusable spacecraft, landed at Edwards Air Force Base, California, on April 14. (National Aeronautics and Space Administration.)

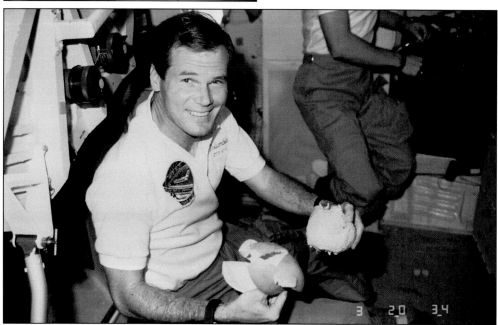

U.S. Congressman William Nelson of Florida enjoys a fresh Indian River grapefruit onboard the space shuttle *Columbia*. The second congressman to fly in space, Nelson served as a mission specialist on STS-61C, launched on January 12, 1986. Upon arrival at California's Edwards Air Force Base, Nelson was greeted by a sign that said, "Welcome to California from the California Citrus Association." (National Aeronautics and Space Administration.)

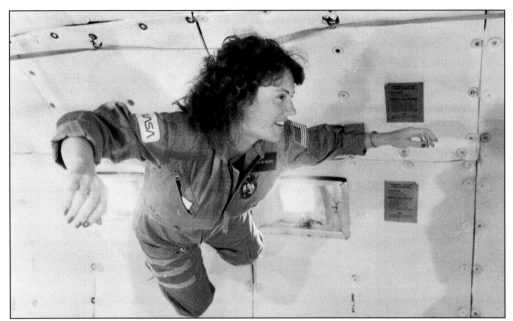

In preparation for the STS-51L *Challenger* mission, schoolteacher Christa McAuliffe went through a zero-gravity exercise aboard a KC-135 aircraft. On January 28, 1986, as millions of Americans proudly watched the launch of *Challenger* and its crew of seven, they witnessed the unbelievable. Seconds after launch, the shuttle exploded, killing the entire crew. A horrified flight controller at the Kennedy Space Center reported, " . . . the vehicle has exploded."

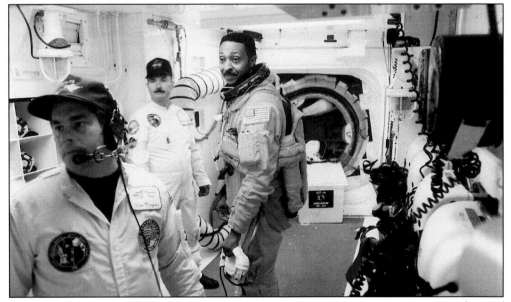

One of Florida's own, Winston E. Scott, was born on August 6, 1950, in Miami. A graduate of Coral Gables High School and Florida State University, he earned a Master of Science degree in aeronautical engineering from the United States Naval Postgraduate School. He logged more than 4,000 flying hours in 20 different military and civilian aircraft. Winston Scott served as a mission specialist on STS-72 and STS-87, making three space walks totaling 19 hours and 26 minutes. (National Aeronautics and Space Administration.)

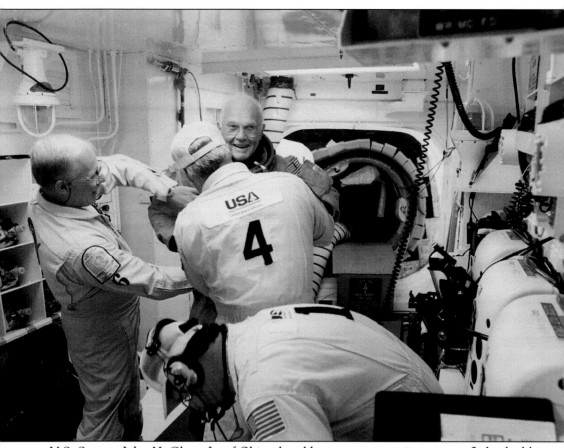

U.S. Senator John H. Glenn Jr. of Ohio, the oldest man to experience space flight, had his flight suit checked in the environmental chamber or "white room" at the Kennedy Space Center. Nine days after launch, payload specialist Glenn and six other crew members of the space shuttle *Discovery*, STS-95, returned to Earth at 12:04 p.m. on November 7, 1998. Of his first view of the Earth from space after 36 years, Glenn reflected, "To look out and see that [Earth] once again, it's sort of overwhelming. I know the word 'awesome' gets overused these days, but if anything is really awesome, it's looking out from up here and seeing that for the first time." The mission of 3.6 million miles was sparked by controversy concerning Glenn's second flight into space. In typical American fashion, there was great debate and editorializing over Glenn's suitability as an astronaut at 77 years of age. Controversy disappeared at launch time as Americans hoped for the safe return of an American hero. (National Aeronautics and Space Administration.)

Ten

WINGS OVER FLORIDA

Were people meant to fly? Imagine Charles Hamilton in 1906 on the white beaches of Florida. He climbed into his aircraft as his assistants attached ropes to his rickety skeleton-framed glider and an automobile. The automobile started up and, constantly picking up speed, headed down the beach. Suddenly the slack rope became taut and Hamilton's glider was pulled across the sand. Quickly the glider was airborne only a few feet. Heading into the wind, the glider climbed higher and higher. Hamilton released the towrope and was on his own. The principle remains the same—with modifications. Pictured is a two-passenger glider soaring high above the Seminole-Lake Gliderport in central Florida. Today, gliders are towed by airplanes to a prescribed altitude and released. Smoothly, gracefully, seemingly effortlessly, and almost without sound, the pilot catches a thermal and spirals up and up until the cities of Orlando and Tampa are visible. Were people meant to fly? Of course, and Florida remains the perfect place. (Seminole-Lake Gliderport.)

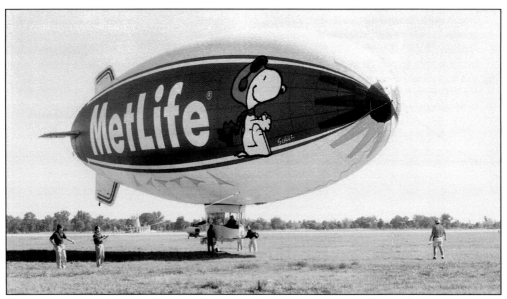

The first reported dirigible flight in Florida took place in Jacksonville in 1908 with Lincoln Beachey at the controls. Dirigibles have been a part of Florida's aviation history ever since. Today, it is an almost common sight to see dirigibles in Florida skies, especially at sporting events where they are used to provide television coverage. The MetLife airship *Snoopy One* prepares to ascend above its winter base at the St. Petersburg-Clearwater International Airport in February 1999. (Private Collection.)

The successful launch and landing of a dirigible requires a ground crew of nine. Four crew members hold the car, or gondola, while two more are required to hold onto each of two ropes on the front. A crew chief directs the ground operation. As it did a century ago, Florida offers airships ideal flying weather—sunny with a bit of breeze. (Private Collection.)

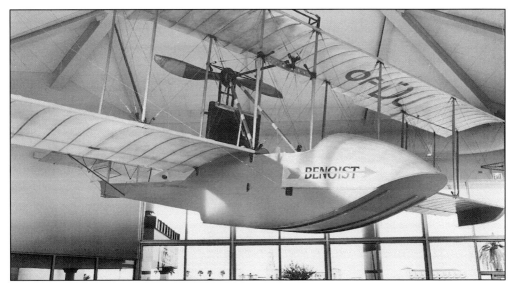

The result of thousands of hours of design and construction, a reproduction of a Benoist flying boat hangs from the ceiling of the St. Petersburg Museum of History. This copy was flown on January 1, 1984, recreating the historic inaugural flight of the world's first airline, the St. Petersburg-Tampa Airboat Line. In June 1995, the Air Transport Association celebrated the ten billionth passenger to be carried on America's airlines. This all began in St. Petersburg on January 1, 1914. (St. Petersburg Museum of History.)

Each year since 1964, the chambers of commerce of St. Petersburg and Tampa have honored individuals in the field of aviation for their contributions toward the advancement of the airline industry. Recipients of the Tony Jannus Award have included pioneers such as Juan Trippe, Eddie Rickenbacker, and Herbert Kelleher. Pictured are (left to right) Thomas Reilly, author of *Jannus, an American Flier*, and the 1997 Jannus Award recipient, General Charles "Chuck" Yeager, the first person to break the sound barrier. (Private Collection.)

Pan Am/National
Schedules
Winter & Spring
1980

Pan Am/National
Schedules
Winter & Spring
1980

National Airlines

PAN AM

While Florida may be considered the birthplace of several airlines, it has unfortunately been the burial ground for just as many. National Airlines ended a 46-year history when it merged with Pan American in 1980. Eastern Air Lines' Great Silver Fleet stopped flying on January 18, 1991. After a decade of massive financial losses and the wanton destruction of Pan Am 103 over Lockerbie, Scotland, Pan American, long known as the "world's most experienced airline," ceased flying on December 4, 1991. (Private Collection.)

Florida's airports started out as cow pastures and sandy beaches along the Atlantic Ocean. In small airplanes, the first airlines carried few passengers. Eighty-five years after the birth of the world's first airline in St. Petersburg, millions of passengers each year are carried on thousands of flights offered by hundreds of airlines, both domestic and foreign. Florida boasts some of the most modern airports in the world, as shown by this view of Tampa International Airport. (Hillsborough County Aviation Authority.)

Born on June 28, 1926, in Pensacola, Betty Skelton began flying before she was a teenager. By the time she had graduated from high school, she had earned not only her private pilot's license, but also her commercial and flight instructor's rating. She took up aerobatic flying in 1945. Her repertoire soon included outside loops, outside snap rolls, and upside-down flying. During the 1940s and 1950s she set many women's speed records. (Private Collection.)

St. Petersburg-Clearwater International Airport at Clearwater was the departure point for the third annual 2,200-mile Transcontinental Air Race. On September 4, 1966, Ed Weiner in his famed checkerboard P-51 Mustang crossed the finish line in five hours and forty minutes. For his first-place finish, Weiner, of Los Angeles, won $3,000 and the 3-1/2-foot gold Paul Mantz Memorial Trophy donated by Bob Hope. The Clearwater to Palm Springs Transcontinental Air Race was an attempt to revive the tradition of the famed Bendix Air Race. (Private Collection.)

Born near Pensacola, Jacqueline Cochran learned to fly in the 1920s. In 1938 she won the Bendix Trophy Race. Cochran became the first woman to break the sound barrier in 1953; seven years later, she flew at Mach 2, twice the speed of sound. At the time of her death in 1980, she held more speed, altitude, and distance records than any other pilot, male or female. (Florida State Archives.)

From the earliest days of aviation, women have fought for the opportunity to pilot an airplane. Matilde Moisant, one of the earliest woman fliers, recalled, "In those days, well, to put it this way, it was man's work, and they [men] didn't think it was women's work." Fortunately, things have changed. Joan E. Higginbotham, a graduate of the Florida Institute of Technology, became a member of the latest generation to shoot for space as a NASA astronaut candidate in 1996. (National Aeronautics and Space Administration.)

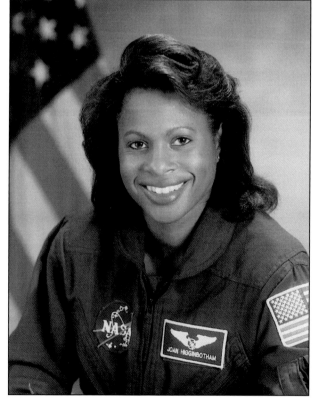

The Blue Angels, the United States Navy's crack aerial exhibition team, was formed following the end of World War II at the order of Chief of Naval Operations Admiral Chester W. Nimitz. Led by Lieutenant Roy M. "Butch" Voris, the Blue Angels performed their first show at Jacksonville Naval Air Station, their home base. Pensacola Naval Air Station became their new home in 1954. The Blue Angels team consists of 15 officers and a support team of approximately 110 navy and Marine Corps enlisted men. (United States Navy.)

The US Air Force's Thunderbirds aerial demonstration team perform a back-to-back Calypso formation over Kissimmee in 1966. During that year, the Thunderbirds performed at Homestead Air Force Base, St. Petersburg, West Palm Beach, and Kissimmee. In their North American F-100D Super Sabres, the Thunderbirds' normal aerial show consisted of loops, Cuban eights, rolls, high bomb bursts, Calypsos, six-ship passes, and victory rolls at air speeds in excess of Mach I (600 miles per hour). (United States Air Force.)

Neither lighter-than-air, heavier-than-air, nor space flight originated in Florida; the contributions made to aviation there, however, are legion. Florida's airlines accomplished many things, including pioneering inexpensive tourist fares that stimulated travel and made the state a hopping-off point as commerce opened up in the Caribbean and South America. One of the most attractive aspects of aviation in Florida is the weather. Few places in the United States are able to boast of such good weather all year long. In the early days of American aviation, Florida's Atlantic beaches offered ready-made landing strips. For the space program, Florida offered good weather and millions of miles of unobscured ocean landing sites. The visionary science fiction writer Jules Verne predicted that space travel would not only be a possibility but would originate in Florida. In *From the Earth to the Moon*, published in 1865, he wrote that the spaceship *Columbiad* was launched from Florida on a trip to the moon. This view of Florida from space shuttle STS-51C, taken in January 1985, leads one to imagine the future contributions of Florida to aviation and America's space program. (National Aeronautics and Space Administration.)